Historic England

Yorkshire

Andrew Graham Stables

AMBERLEY

Acknowledgements

Thanks to my family, the publishers and the good people of Yorkshire who I have lived among for the last thirty-one years and who have almost accepted me as 'someone who lives here'.

First published 2019

Amberley Publishing
The Hill, Stroud, Gloucestershire, GL5 4EP
www.amberley-books.com

The right of Andrew Graham Stables to be identified as the Author of this work has been asserted in accordance with the Copyright, Designs and Patents Act 1988.

The publisher is grateful to the staff at Historic England who gave the time to review this book.

All contents remain the responsibility of the publisher.

ISBN 978 1 4456 9181 7 (print)
ISBN 978 1 4456 9182 4 (ebook)

British Library Cataloguing in Publication Data.
A catalogue record for this book is available from the British Library.

Typesetting by Aura Technology and Software Services, India. Printed in Great Britain.

Contents

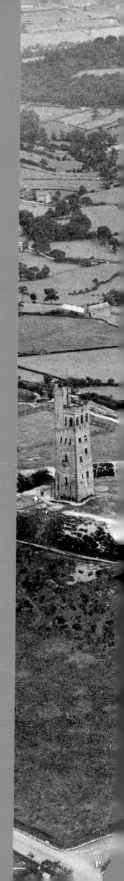

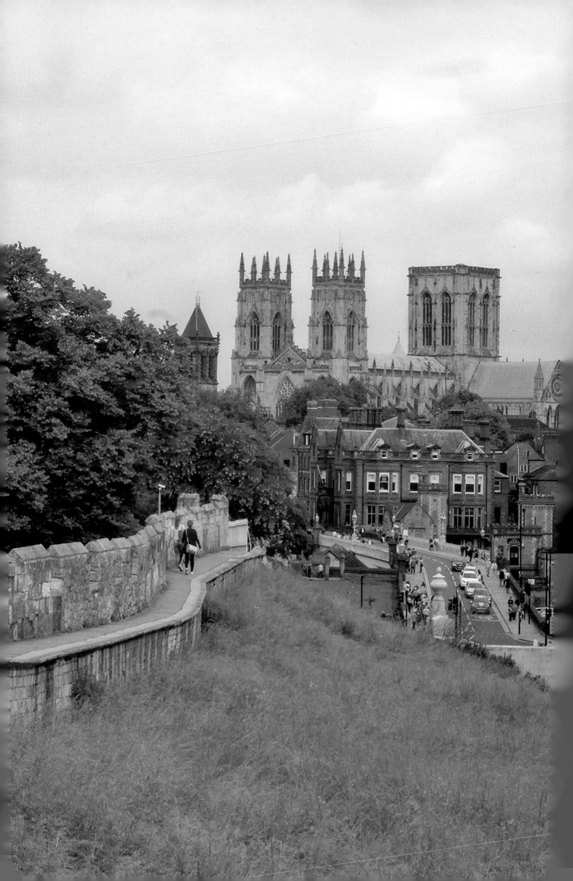

Introduction

'Yorkshire! Yorkshire! Yorkshire!' It is a shout heard on the terraces at football matches, or made by some boastful Yorkshire bands at music venues and enthusiastically chanted on many sports fields throughout this famous county. Yorkshire can claim to be England's largest county with some of the most diverse countryside and, maybe like no other county, can also provide the visitor with a wealth of history, where the ancient sits alongside the medieval, and the industrial past can be found surrounded by modern regeneration. Yorkshire is home to a population of 5,390,576 (2017) contained within four distinct regions called North Yorkshire, West Yorkshire, South Yorkshire and the East Riding of Yorkshire, all contained in an area of 11,903 square kilometres (4,596 square miles).

This book will explore the four corners of the county from the industrial centre of Sheffield to the beauty of historic York, from the important port of Hull to the industrial heartland of Leeds and Bradford. It is a county of huge contrasts with vast swathes of unspoilt, beautiful countryside littered with picturesque villages, and long stretches of an ever-changing coastline with the resort towns of Whitby, Scarborough and Bridlington. West Yorkshire towns like Huddersfield, Halifax and Bradford were the beating heart of the Industrial Revolution and the steel towns of South Yorkshire, like Doncaster, Rotherham and Sheffield, were fuelled by the coal mining industry.

Swaledale is home to Britain's highest pub, the Tan Hill Inn, situated at 1,732 feet (528 metres) above sea level; Sheffield, that once great industrial hub, has the highest ratio of trees to people in Europe; and three prime ministers were born in the county. The most well-known slavery abolitionist came from Yorkshire and the county claims to be the birthplace of club football and Rugby League. York, with its layers of heritage, includes the Shambles, which is believed to be the oldest shopping street in Europe, even being mentioned in the Domesday Book of 1086, and the city has the oldest working convent in England.

Yorkshire contains two national parks: the North Yorkshire Moors and the Yorkshire Dales, both Areas of Outstanding Natural Beauty. It is a county filled with important castles, cathedrals and abbeys from the medieval period, including Richmond Castle, Fountains Abbey and York Minster. It also has stately homes and gargantuan industrial buildings from the age of the empire, including Castle Howard, Harewood House and Salts Mill.

Abbeys

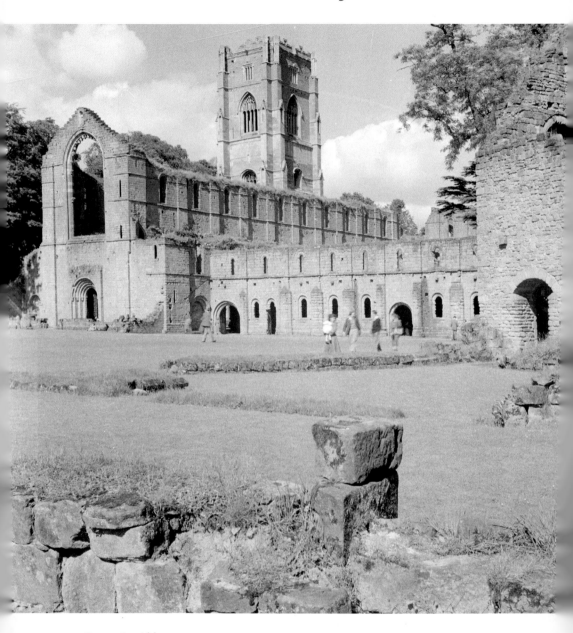

Fountains Abbey
Fountains Abbey, founded in 1132 by thirteen Benedictine monks from St Mary's Abbey in York who were seeking a simpler life, is Britain's largest monastic ruin. The inhabitants later became Cistercian monks but ended up far from those simplistic ideals to become one of the largest, richest and the most influential Cistercian abbeys in Britain. (Historic England Archive)

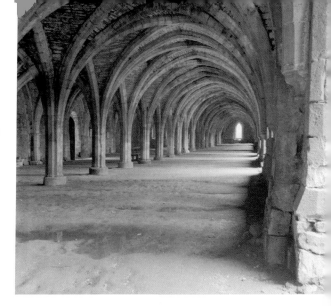

Fountains Abbey Undercroft
The abbey's wealth grew as local families asked for prayers to be said by the monks and the abbey became a hive of industry due to the income from sheep farming. The monks were assisted by lay brothers, who carried out the routine tasks by serving as masons, tanners, shoemakers, smiths and bakers. In the end these monastic houses became moneymaking industrial complexes with farms and granges, lead mining, stone quarries and horse breeding. (Historic England Archive)

Kirkstall Abbey
Monks from Fountains Abbey, funded by their patron Henry de Lacy, acquired the land upon which Kirkstall Abbey stands. The land possessed plenty of timber and stone and had a river running down its centre, so in 1152 the monks began building their new abbey there. (© Historic England Archive. Aerofilms Collection)

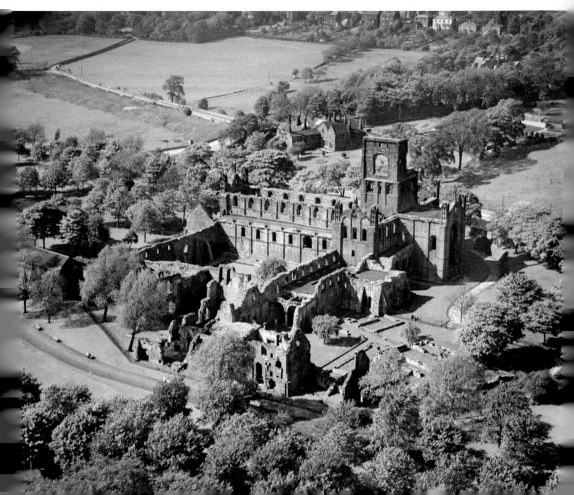

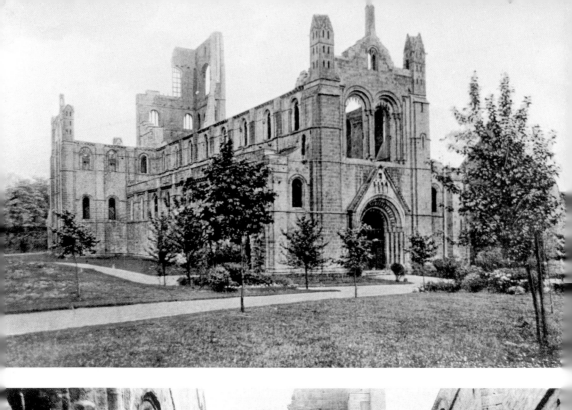
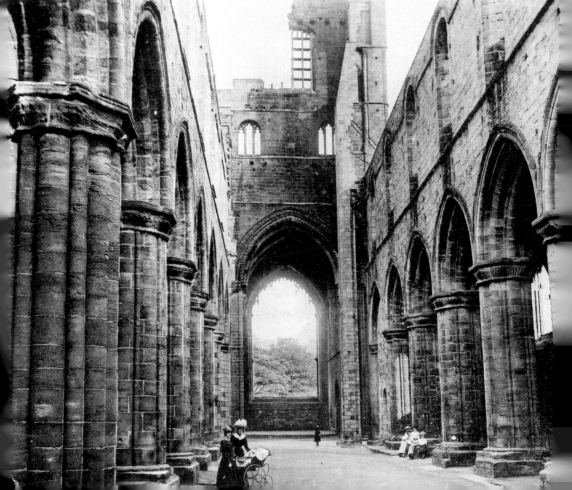

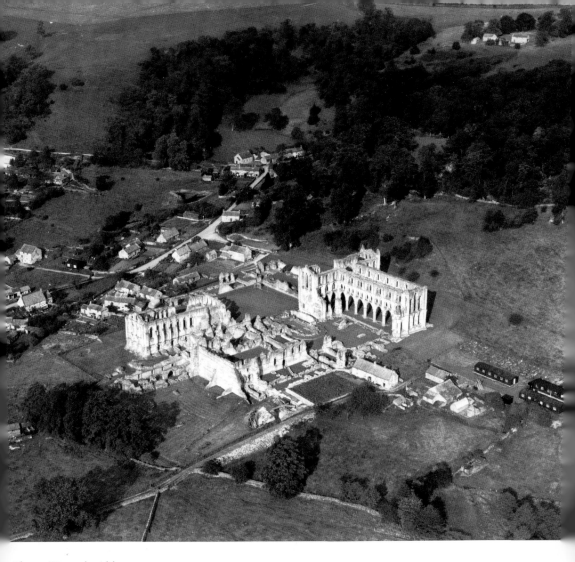

Above: Rievaulx Abbey

This early Cistercian abbey was established in 1132 on land given by Walter Espec (d. 1154), lord of nearby Helmsley and a royal justiciar. He supported ecclesiastical reform and also had nearby Kirkham Priory founded for the reformist Augustinian canons in around 1121. Though the initial buildings were wooden, by the late 1130s they began to construct in stone to create one of the largest and most impressive buildings in Yorkshire. (© Historic England Archive. Aerofilms Collection)

Opposite above: Kirkstall Abbey

The Cistercian monks toiled to clear the land and enriched the soil to grow crops, and as the abbey grew, they were granted more gifts of land and money. The main buildings were erected within thirty years of their establishment, including the great church and chapter house. (Historic England Archive)

Opposite below: Kirkstall Abbey

This photograph, taken before 1900, shows women and children looking around the ruined nave of Kirkstall Abbey. (Historic England Archive)

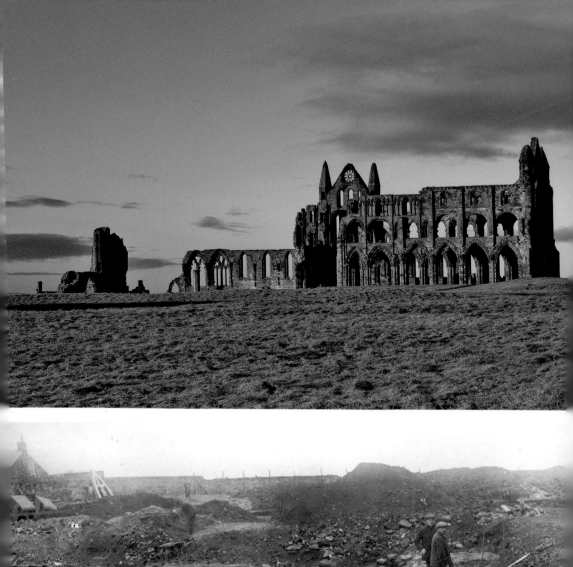
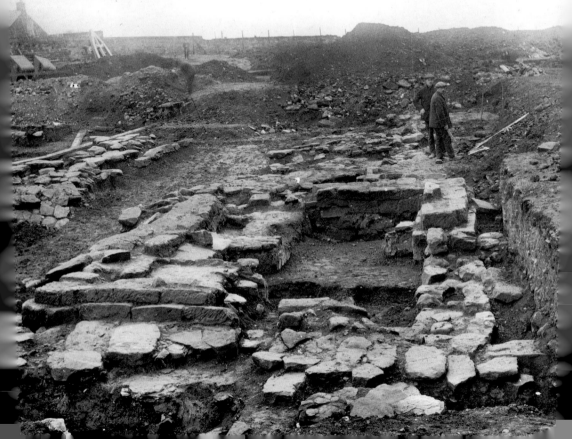

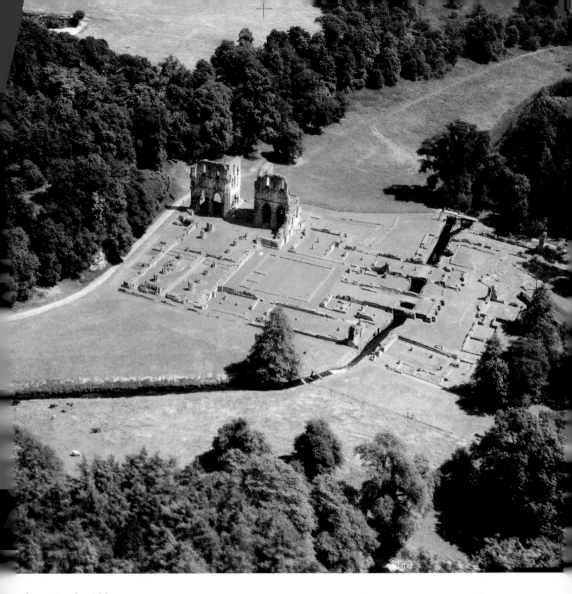

Above: Roche Abbey

Roche Abbey, though founded in 1147 as a monastery of the Cistercian order, peaked around 1175, when it was home to around fifty monks and 100 lay brothers. Following the Reformation in 1538 many of the buildings were dismantled, leaving the romantic ruins, which in the 1770s became the centrepiece of a Capability Brown-designed landscape created for the Earls of Scarbrough. (© Historic England Archive. Aerofilms Collection)

Opposite above and below: Whitby Abbey

The first monastery in Whitby was founded around 657 and became one of the most important Anglo-Saxon religious sites in the country. According to Bede it was in 664 when the monastery was used as the location of the Synod of Whitby, where the fate of the two sides of Christianity in England, the Celtic and the Roman, were to be decided. In the end it was decided that the Roman side should prevail, and the pope's authority was gradually established over the Church in the British Isles. The building dominant on the site now is the ruined thirteenth-century church of the Benedictine abbey founded after the Norman Conquest. The excavations carried out in the mid-1920s revealed the foundations of the Saxon church. (Author; Historic England Archive)

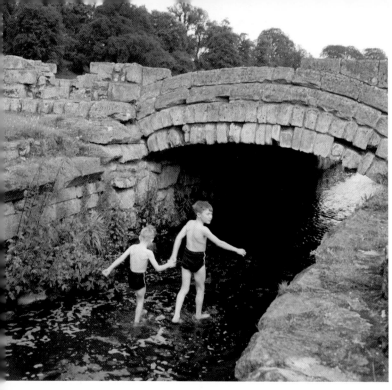

Roche Abbey
Two boys wading along
Maltby Beck at Roche
Abbey in the 1950s, heading
towards a supporting
arch over the water.
(Historic England Archive)

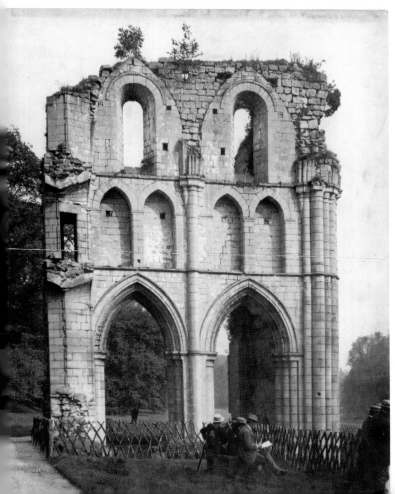

Roche Abbey
A photograph from the
early 1900s showing
the remaining north
transept at Roche Abbey.
(Historic England Archive)

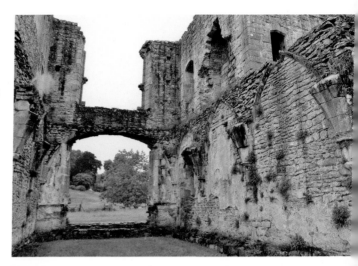

Right and below: Easby Abbey
Easby Abbey was founded around
1152 by Roald, a constable of
Richmond, who granted a modest new
endowment of land, adding to the assets
of the existing minster community.
The abbey's benefaction rose over the
years, increasing their land for livestock,
mainly sheep. The abbey seems to have
prospered in the late twelfth century
and the number of canons increased.
It expanded in 1198 to Egglestone
Abbey in nearby Teesdale, which was
founded as Easby's daughter house.
(Author; © Historic England Archive.
Aerofilms Collection)

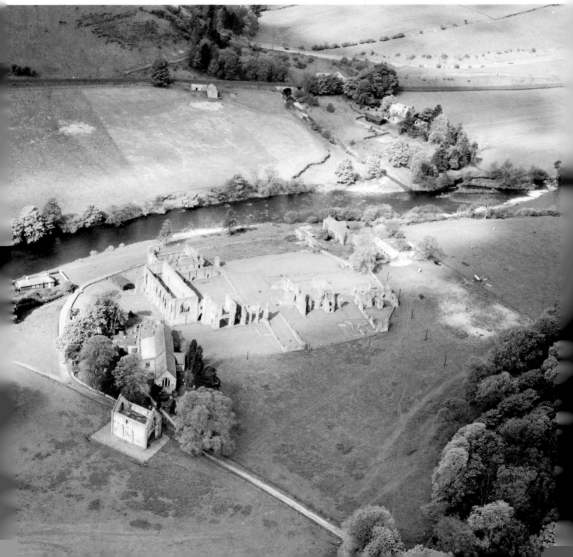

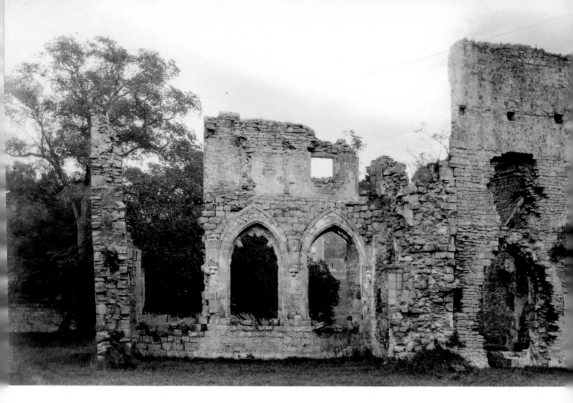

Above: Easby Abbey
As the abbey prospered the original buildings were replaced but on a much grander scale and only parts of the buildings before the late twelfth century can still be traced. (Historic England Archive)

Below: Easby Abbey
In 1535 when the abbeys were being suppressed by Henry VIII and Thomas Cromwell, Abbot Robert Bampton (1511–36) restated the rights of the Scropes as patrons and the abbey continued as others were closed down. However, the writing was on the wall, and with a community of just eleven canons, in 1536 the abbey was dissolved and its lands were let to Lord Scrope of Bolton for £300. (Historic England Archive)

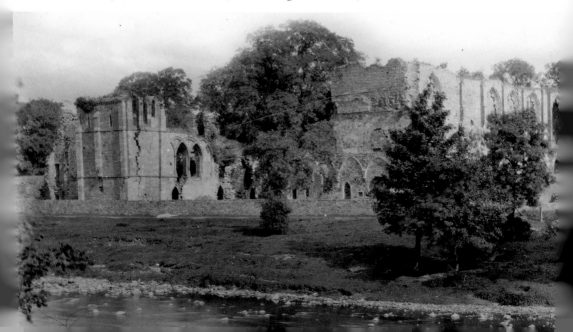

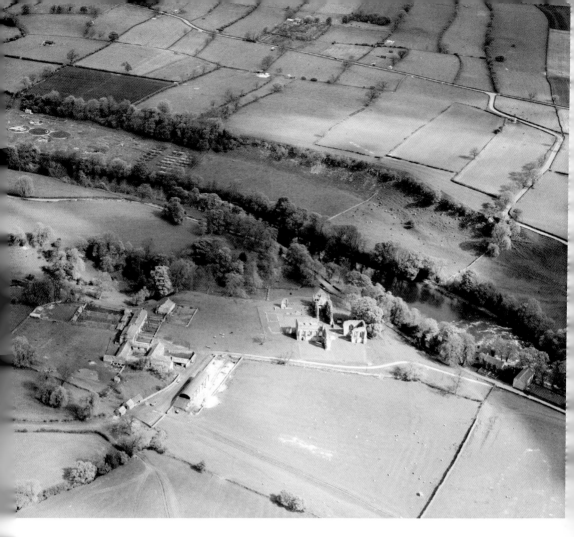

Egglestone Abbey
Located at the point where Thorsgill Beck meets the River Tees and on a steep-sided promontory, Egglestone Abbey was established between 1195 and 1198 by Premonstratensian canons. © Historic England Archive. Aerofilms Collection)

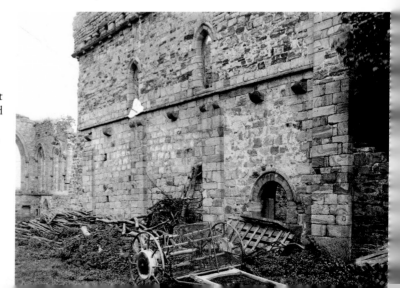

Egglestone Abbey
After the Dissolution of the Monasteries, the site was granted by the Crown to Robert Strelley (1548) and he converted the east and north ranges into a mansion with a kitchen in the west range. This photograph shows the north wall of the nave with machinery and felled wood stacked in front of it. Historic England Archive)

Above: Egglestone Abbey
In 1770 Sir Thomas Robinson sold the abbey to John Morritt of Rokeby Hall and Morritt's descendant placed the ruins in the guardianship of the state in 1925. The site includes the tomb of Sir Ralph Bowes of Streatlam (d. 1482), which was later repositioned in the church crossing. This photograph shows the tomb in Mortham Wood at Rokeby before it was moved to its present location. (Historic England Archive)

Below: Byland Abbey
Originally the site of Byland Abbey was marshland, but the monks settled on this location and began to drain the land, probably in the late 1150s, and the buildings were inhabitable by 1177. The construction of the great church as well as other support buildings would have taken a few more years to complete. (Historic England Archive)

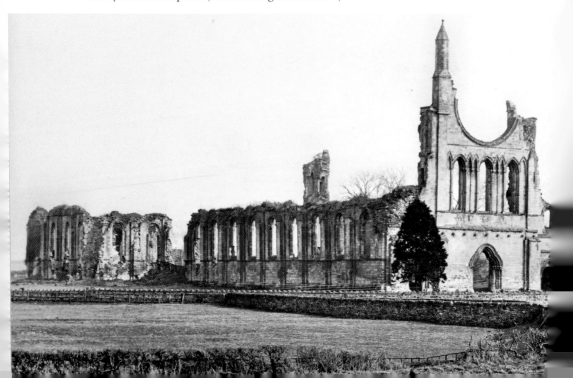

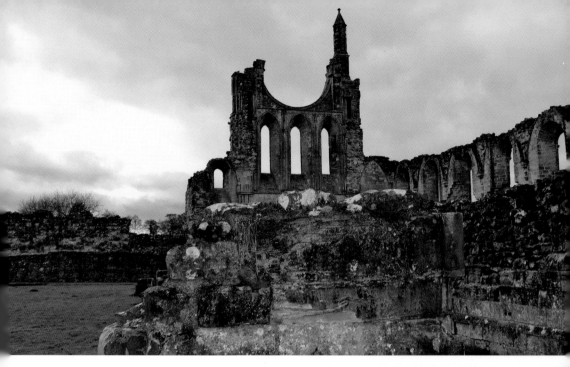

Above and right: Byland Abbey
The new monastery was overseen by
Abbot Roger, a capable administrator
who successfully built up the economy
of the abbey. Grants came from various
benefactors, but principally from
Roger de Mowbray, who was regarded as
Byland's founder. (Author)

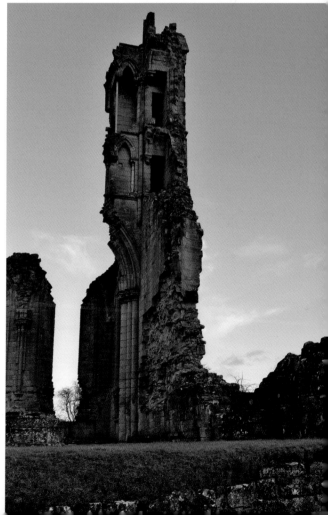

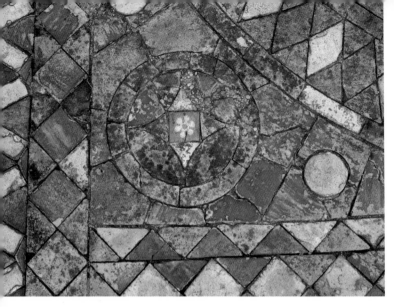

Byland Abbey
Following the suppression of the monasteries they were gutted of all valuable items. The plate was valued and shipped to London, while the buildings were stripped of lead, glass and timber. Byland and its estates were then granted to Sir William Pickering in 1540. The grandeur of the building can be seen in this view of floor tiles in the ruined abbey's south transept. (© Historic England Archive)

St Mary's Abbey
St Mary's Abbey, York, was first built in 1088, and became the largest, wealthiest and most powerful of all Benedictine institutions in northern England. The abbot was recorded in the Domesday Book as one of York's largest landowners. The abbey estate occupied the entire site of the modern-day Museum Gardens and the abbot was almost as powerful as the Archbishop of York. (Author)

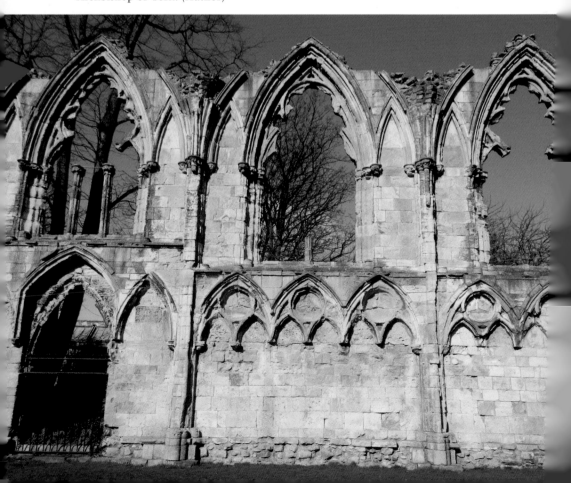

Cathedrals, Minsters and Churches

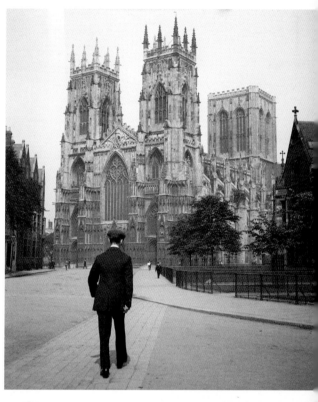

York Minster
The site of the minster has always been at the heart of the city. The remains of the ceremonial centre of the Roman fortress were found beneath the minster building, with one of the columns now exhibited to the south of the building. The first Christian church on the site is believed to have been established in 627 and the first Archbishop of York was recognised by the pope in 732. The earlier church was destroyed following the Norman invasion, but it was William the Conqueror who appointed the next archbishop and built a Norman cathedral on the site. The present incarnation was built between 1220 and 1472 and is considered to be one of the finest medieval buildings in Europe. (Historic England Archive)

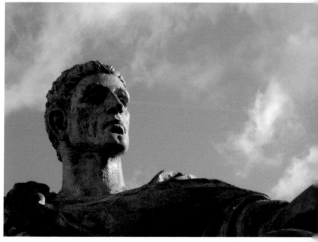

Constantine the Great, York
The statue of the Roman emperor Constantine the Great stands outside York Minster. He arrived in Britain with his father, Emperor Constantius, in 305, and when Constantius died in York the following July, Constantine was declared emperor. He ruled until AD 337 and went on to become one of the most significant Roman leaders. He reunited the whole of the empire after years of fractures and supported Christianity as the official faith of the Roman Empire, an act that had an incalculable impact on European and world history. (Author)

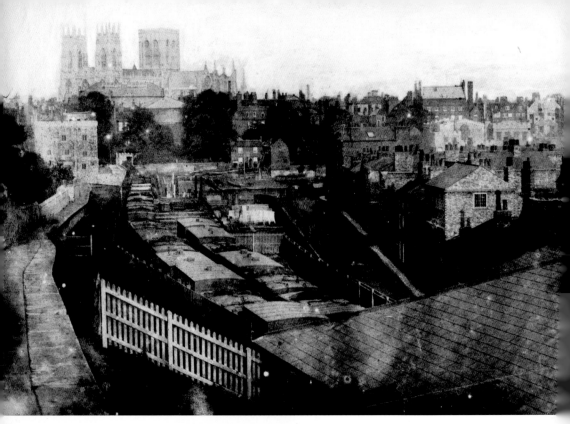

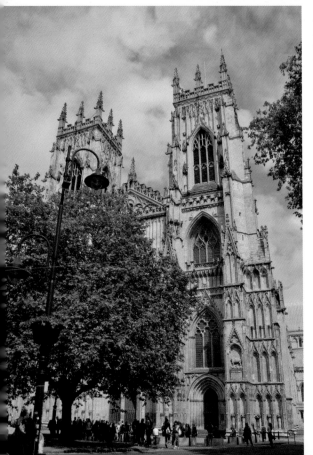

Above and left: York Minster
An early photograph looking over the city towards York Minster from the city wall, where in the foreground, running alongside the wall, are the coal drops and sidings of the York and North Midland Railway. The other image is taken from Duncombe Place in 2018. (Historic England Archive; Author)

Ripon Cathedral

Ripon Cathedral was built between 1180 and 1260, but it is on the site of one of the oldest stone buildings in the country. St Wilfrid's crypt was built around 672 and is the only part of the original church on this site to have survived. This crypt from the first century of English Christianity is still accessible today and well worth a visit. (Historic England Archive)

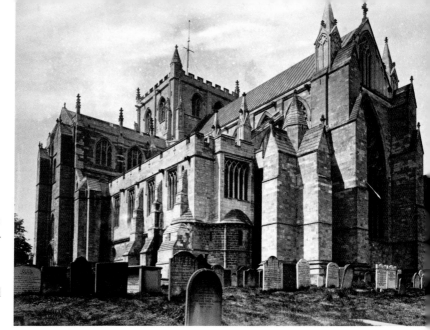

Ripon Cathedral

This aerial photograph shows Ripon Cathedral, one of the oldest Christian sites in Britain, and the city centre in 1921. (© Historic England Archive. Aerofilms Collection)

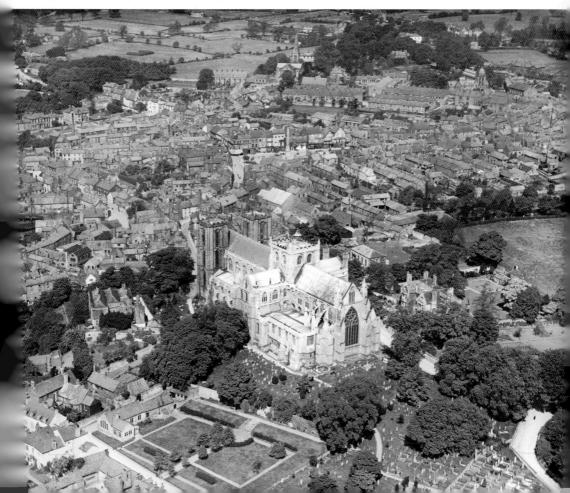

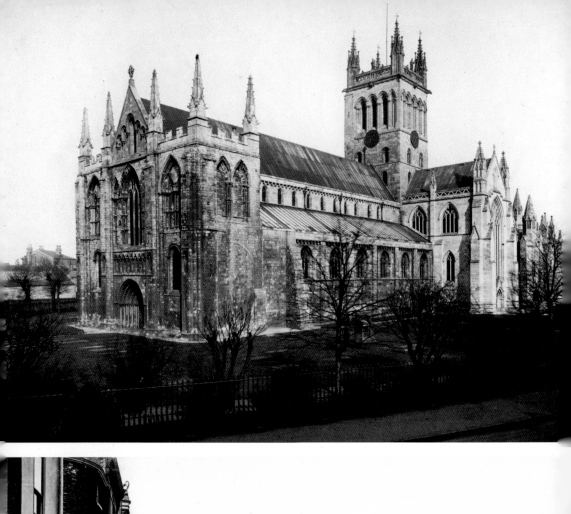

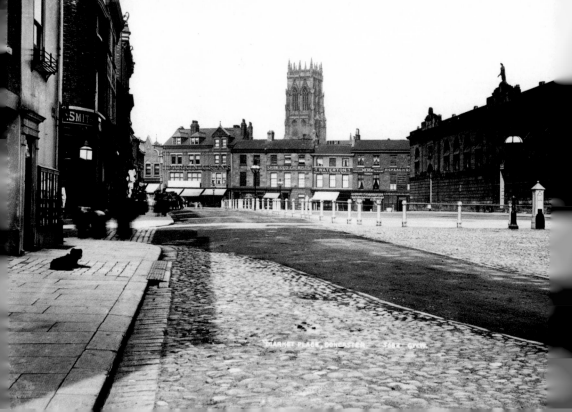

MARKET PLACE, DONCASTER

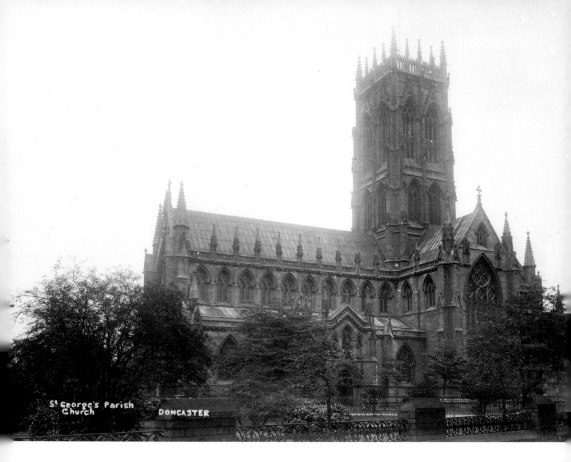

Above: St George's Minster, Doncaster
A Norman fortification is also known to have previously occupied the site of St George's, and it is likely that stone from this building was used in the construction of the early church. The early church was destroyed by fire on the night of 28 February 1853. With great determination and the designs of George Gilbert Scott, a new church took only four years to build, and the new building was consecrated by the Archbishop of York on 14 October 1858. (Historic England Archive)

Opposite above: Selby Abbey Church
Not actually a cathedral, but the ancient settlement of Selby boasts an early Norman abbey church that is actually larger in size than many English cathedrals. It was due to a monk called Benedict from Auxerre in France who persuaded William the Conqueror to give him permission to found an abbey at Selby. His successor, Hugh, was responsible for constructing the great church. (Historic England Archive)

Opposite below: St George's Minster, Doncaster
The Market Place with a view towards the tower of St George's Minster, a church that occupies the site of the Roman fort of Danum and includes a section of the fort wall at the north-east end of the minster site. (Historic England Archive)

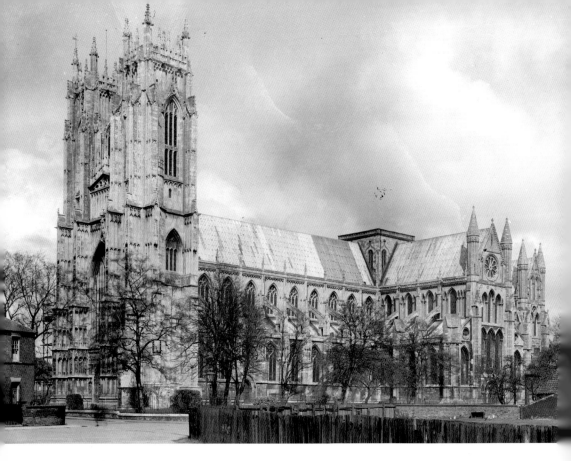

Beverley Minster
Beverley Minster is believed to be have been built on the site of an eighth-century monastery, but the structure we see now began in 1190 and was added to over the next 200 years, taking in different styles and incorporating some of the old. Following the Reformation, the minster is only described as being in a state of decay, until the eighteenth century when money was raised by a national appeal to stabilise and restore the building. Further works were carried out in the nineteenth century, although they actually undid some of the earlier restoration. A new bell was added when the old bells were arranged for an overhaul in the early 1900s. (Historic England Archive)

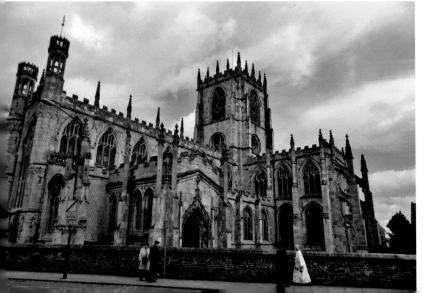

St Mary's Beverley
Beverley not only has a minster but also has one of the most beautiful parish churches – St Mary's. The church is said to be so architecturally significant because of its continued development throughout 400 years of history between the years 1120 to 1530. (Author)

Castles and Fortifications

Thornborough Henge

Near West Tanfield are a set of three Neolithic henges that are aligned north-west to south-east on flat land between the rivers Ure and Swale. They are all roughly the same size (between 240 and 275 metres across) and stand some 3 metres in height. The exact purpose of the site is unclear, but as burial mounds there is some suggestion they were used for ceremonial processions and meeting points. Linked by corridors and in the shape of constellations, they may have involved astronomical worship. (© Historic England Archive)

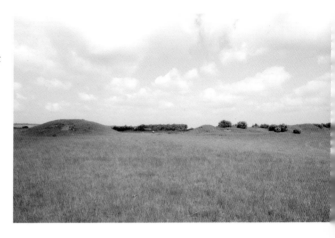

Stanwick Iron Age Fortifications

Stanwick Iron Age Fortifications cover an area of over 300 hectares (750 acres) and are located just off the junction of the A1 and A66, known as 'Scotch Corner'. Excavations carried out by Sir Mortimer Wheeler in the 1950s exposed many artefacts and a section of the earthworks was restored to show how they would have originally looked. Home to a tribe called the Brigantes, a queen called Cartimandua acquiesced and indeed collaborated with the Roman invaders. This policy may have been sensible at the time, but within a few years the Romans moved north and took over the whole country. (Historic England Archive)

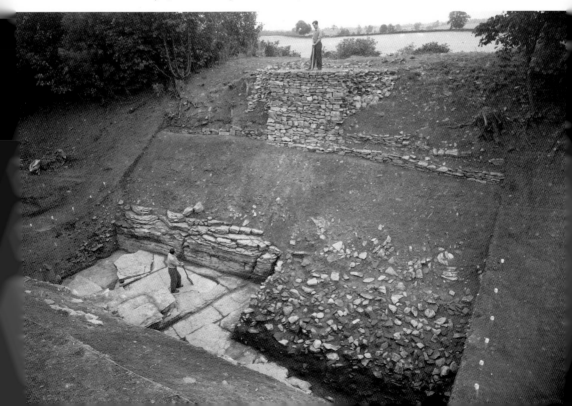

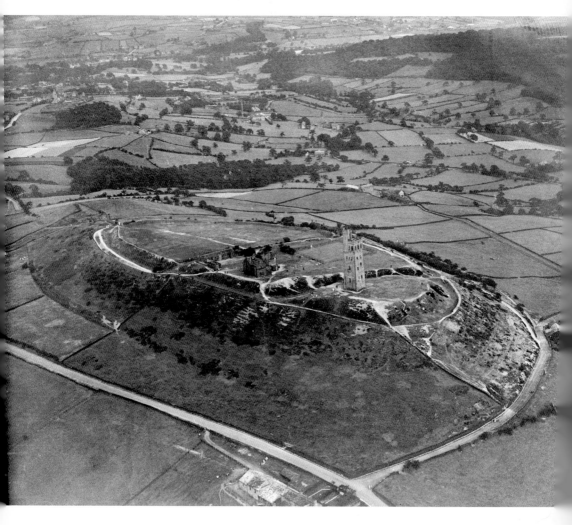

Castle Hill, Almondbury

Castle Hill, near Huddersfield, has been the site of a settlement since around 2100 BC. Iron Age defences were later built on by the Normans when a motte-and-bailey castle was built in the eleventh century. Elevated over 300 metres above sea level, the site dominates the Holme Valley and the River Colne, a vital artery for trade and communication over thousands of years. The castle was abandoned in the late thirteenth century and was reported a ruin by 1320. A public house was built on the hill in the nineteenth century and in 1897 a large folly, the Victoria Tower, was built to celebrate Queen Victoria's Silver Jubilee. During the Second World War an anti-aircraft battery was installed on the site. (© Historic England Archive Aerofilms Collection)

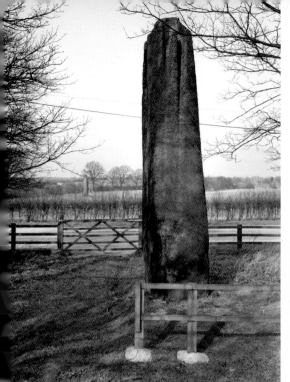

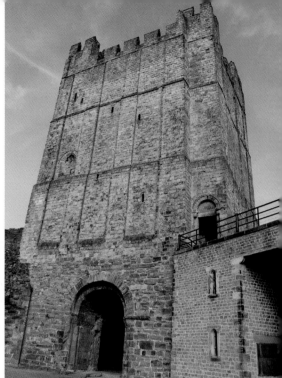

Above left: Devil's Arrows, Boroughbridge

The Devil's Arrows are three standing stones (originally thought to number four or five) that stood in a south-east to north-west alignment less than 200 metres from the modern-day A1 (M) motorway. They are believed to date from the late Neolithic or early Bronze Age. (© Crown copyright. Historic England Archive)

Above right: Richmond Castle

Richmond Castle is one of the earliest stone-built castles in the country, and no other in England can boast so much surviving eleventh-century architecture. Count Alan Rufus ('the Red') was granted vast lands in the north following his service to William the Conqueror at the Battle of Hastings. Building work is believed to have started soon after 1071 to suppress the recently dispossessed Anglo-Saxon nobility and establish Norman power in the north. (Author)

Richmond Castle
The earliest sections of the castle include some of the curtain wall, the great archway in the ground floor of the keep and Scolland's Hall. This photograph shows the Cockpit gateway and the heavily shored east curtain wall. (Historic England Archive)

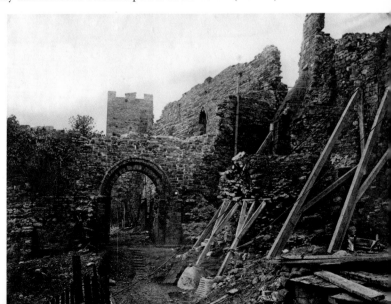

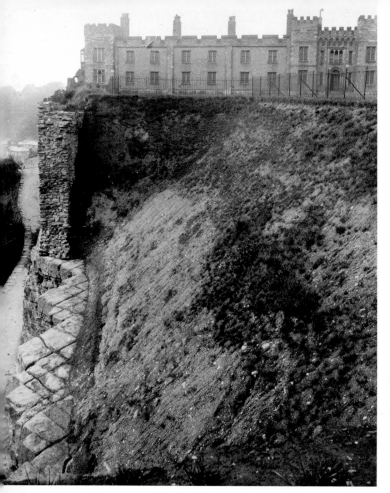

Richmond Castle
The Victorian period saw a return of use for the castle and in 1854 the castle was leased out to the North York Militia. Within the year a barrack block was built next to the west curtain wall and keep, modified with the addition of a reserve armoury building next to it. By 1908 the castle became the headquarters of the Northern Territorial Army and Robert Baden-Powell, who went on to found the Boy Scouts, commanded for a short time. The Victorian barracks were demolished in 1931. (Historic England Archive)

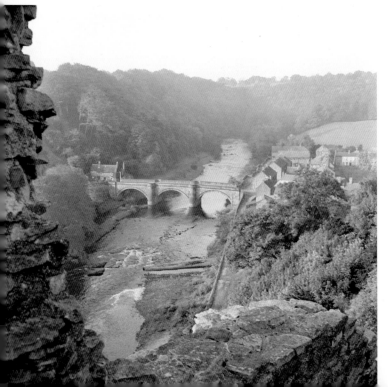

Richmond Castle
Richmond Castle is positioned on a high promontory above the River Swale and is strategically important to the main crossing points. This view, looking down onto the river from Richmond Castle, demonstrates the advantageous position. (© Historic England Archive)

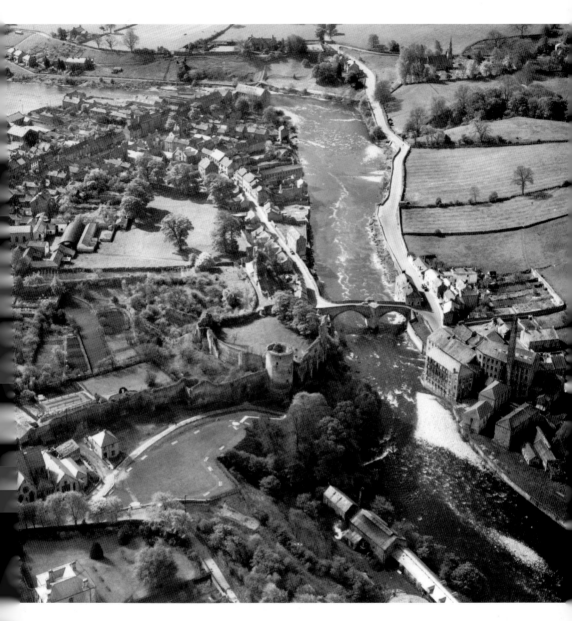

Yorkshire Border
The River Tees used to form the northern border of the county, and only changed in 1974 when the political boundaries were modified. This photo of the Tees at Barnard Castle shows Yorkshire on the right-hand side and County Durham on the left-hand side. The bridge straddling the Tees is still known as the County Bridge. (© Historic England Archive. Aerofilms Collection)

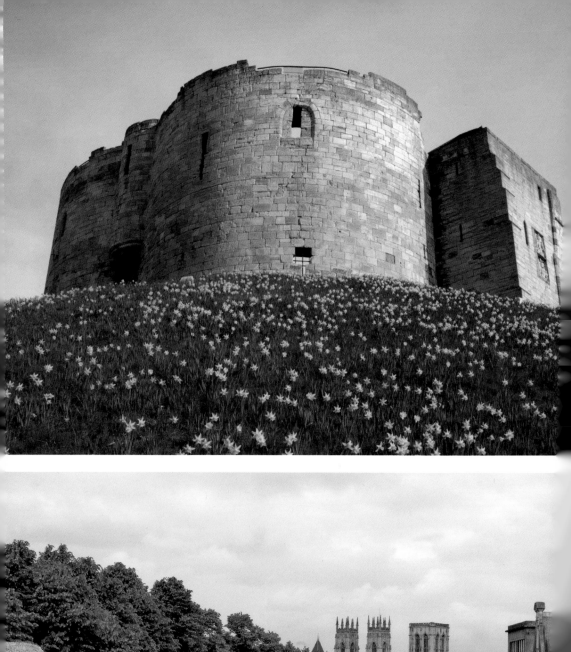
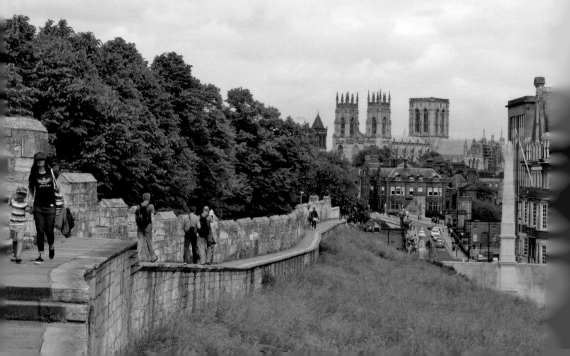

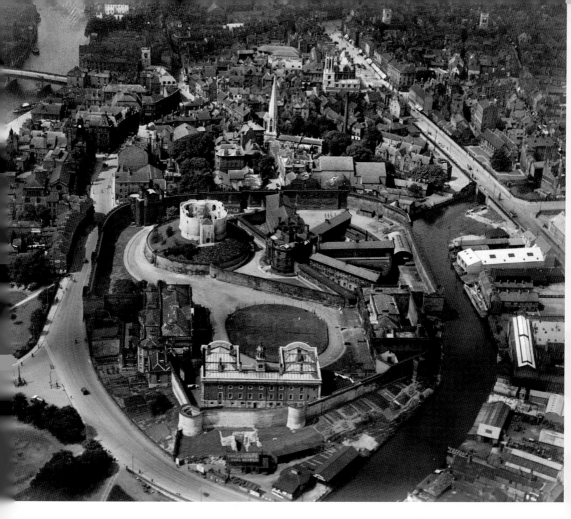

Above: York Prison
This view of York shows the huge wall surrounding the whole castle site, built in a dark millstone between 1825 and 1835. The ancient North Gate was demolished and replaced with a new gate in the north-west corner of the site. The four prison blocks were built in a wheel around the hub, which was the governor's residence and administration block. It was used as a prison until 1900, after which it became a military detention centre before finally being demolished in 1934 and made into a car park. (© Historic England Archive. Aerofilms Collection)

Opposite above: Clifford's Tower, York
Part of the original York Castle complex, Clifford's Tower stands on top of a motte. The original wooden castle was burnt down when the northerners rebelled against Norman rule, whose retribution was swift and brutal. The devastation that followed became known to history as the Harrying of the North and it took generations to recover from the whole experience. What would have been the bailey now contains law courts and a museum – seen in the above image. (© Historic England Archive)

Opposite below: York Walls
York has the most complete example of medieval city walls still standing in England today, and this view on the west side of the city also shows the minster in the background. The gates, known as 'Bars', still dominate the old entrances to the town, with Micklegate Bar regularly furnished throughout history with the heads of traitors. (Author)

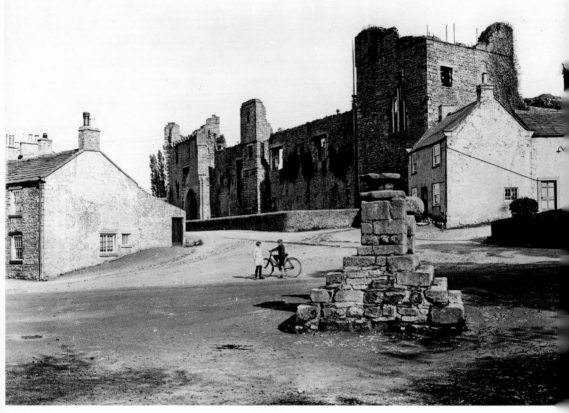

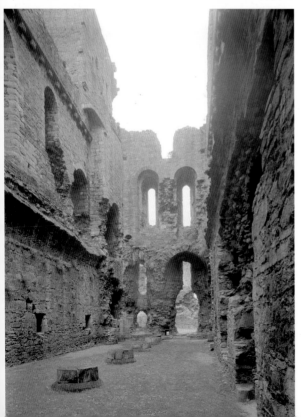

Above and left: Middleham Castle
This imposing fortress is best known as one of the childhood homes of Richard III and the residence of the powerful Neville family, who were influential in English affairs for over two centuries. The Norman tower is one of the largest in the country and its walls some of the most impregnable of any castle in the land. Richard, Duke of Gloucester (later Richard III), spent a lot of his youth at Middleham and after the fall of Warwick ('the Kingmaker') it became one of his royal homes. Richard was married to Anne Neville, the youngest daughter of the Kingmaker. (Historic England Archive)

View in Castle Ground, Pontefract.

Pontefract Castle

Pontefract Castle used to be the one of the most important and secure castles in the country, second only to the Tower of London. The castle is said to have been built on old Saxon burial grounds, and its dungeons were the scene of Thomas, Earl of Lancaster's execution and Richard II's murder. However, today the castle is almost completely ruined after being one of the last remaining strongholds for the Royalists during the English Civil War, even holding out for two months after the death of King Charles. The castle was destroyed by gunpowder and a team of men with picks and shovels, but it took so long and was so expensive that other castles were 'slighted' instead to prevent further use. (Historic England Archive)

Knaresborough Castle

Always considered to be a royal stronghold, Knaresborough Castle is linked with a high number of significant figures, including the knights who murdered Thomas Beckett, and with King John, Edward I and II, Piers Gaveston, Richard II and John of Gaunt. Perched high above the River Nidd, the earliest mention of a castle here is 1130, though the visible ruins date to the fourteenth century. (Historic England Archive)

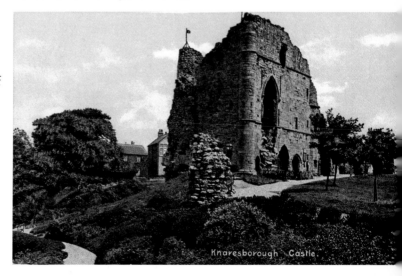

Knaresborough Castle.

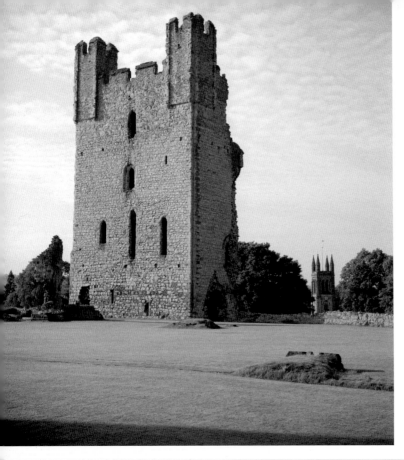

Left and below: Helmsley Castle
This medieval castle survived without conflict up until the English Civil War when Helmsley was held by the Royalists. From September through to November 1644, Parliamentary forces surrounded the castle and forced the garrison to surrender through lack of supplies. The keep and walls are evidence of the 'slighting' of the castle to prevent further military use. The Tudor mansion was left intact and is well worth a visit. The entire site is in the hands of English Heritage and various exhibitions tell the story of the castle. (Historic England Archive; © Crown copyright. Historic England Archive)

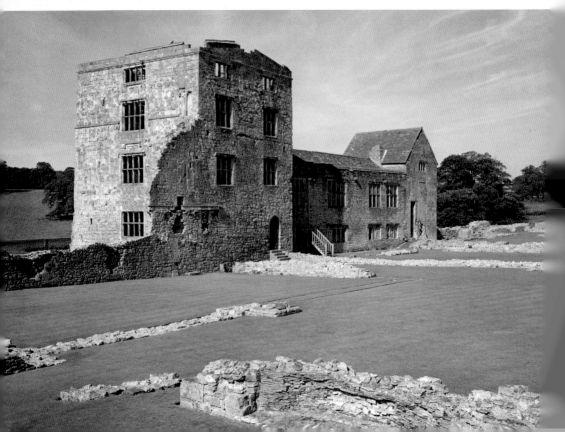

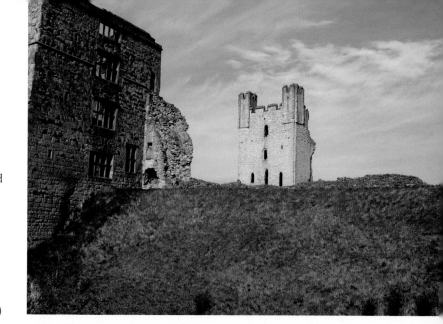

Right and below: Helmsley Castle Originally consisting of two massive earthwork banks and ditches topped with wooden palisades, the castle was built in stone between the twelfth and fourteenth centuries. (Author; © Historic England Archive. Aerofilms Collection)

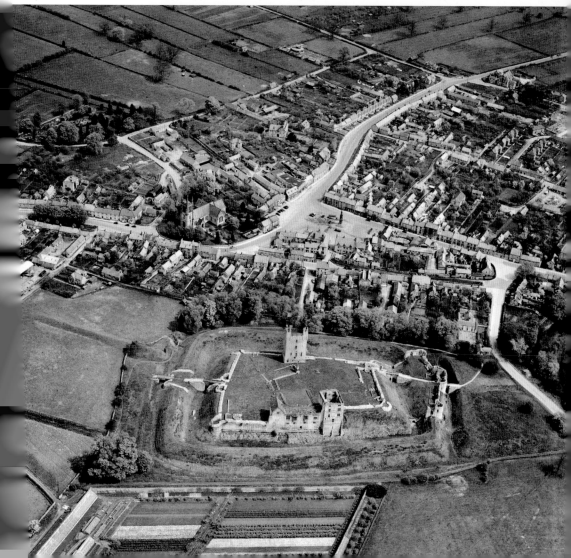

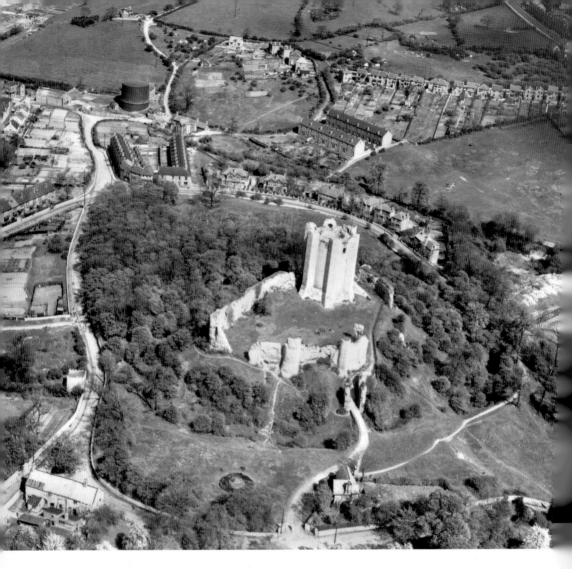

Above: Conisbrough Castle
The lordship associated with Conisbrough Castle was given by William the Conqueror to William de Warenne. The keep is regarded as one of the finest in England, and was probably built in the 1170s or 1180s. The site became a picturesque ruin in the eighteenth and nineteenth centuries, and inspired Sir Walter Scott's most famous 1819 novel, *Ivanhoe*. (© Historic England Archive. Aerofilms Collection)

Opposite above: Pickering Castle
Reconstruction illustration showing an aerial view of the motte and bailey at Pickering Castle as it may have appeared early in the twelfth century while still under construction. Originally built in timber, this thirteenth-century castle sits in the heart of the North York Moors National Park and saw little action. Its proximity to the surrounding parkland proved very popular with a number of kings and was often used as a royal hunting lodge and, for a time, a stud farm. (© Historic England Archive)

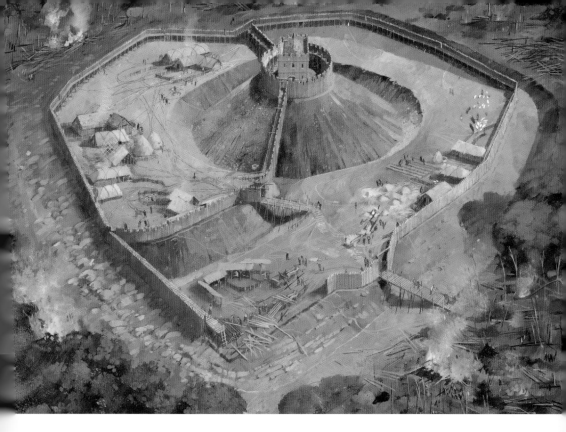

Below: Skipton Castle

The history of the castle is inseparable from the Clifford family, who were granted the property by Edward II in 1310 when Robert Clifford was appointed 1st Lord Clifford of Skipton and Guardian of Craven, the wide tract of countryside to the north and west of Skipton. The Cliffords' Norman forebears took the name from Clifford Castle in Herefordshire, which they also owned. Robert Clifford began heavily fortifying the castle, but he was killed at the Battle of Bannockburn in 1314 with his new stronghold barely completed. (Historic England Archive)

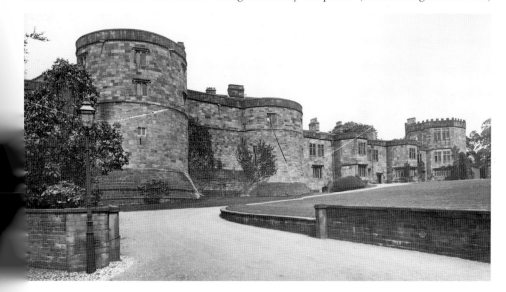

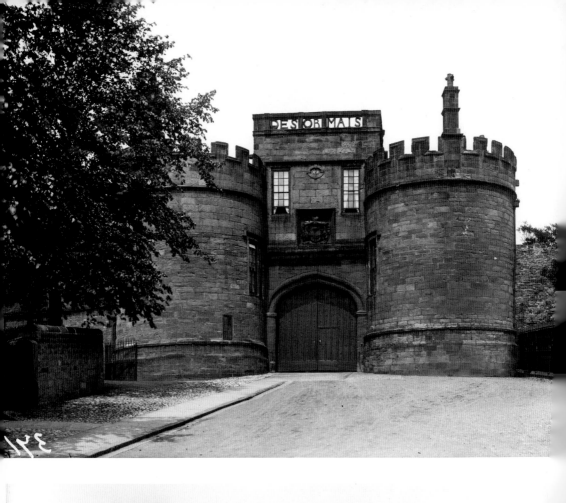

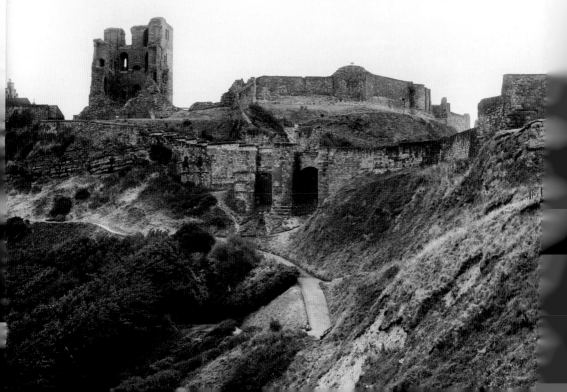

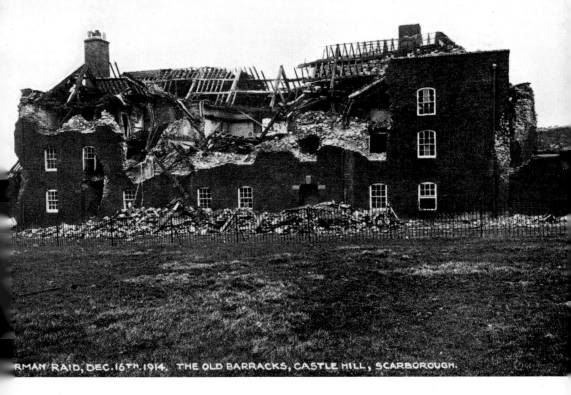

RMAN RAID, DEC.16ᵀᴴ.1914. THE OLD BARRACKS, CASTLE HILL, SCARBOROUGH.

Above: Scarborough Castle
It was 8 a.m. on Wednesday 16 December 1914 when the morning silence was shattered by two German battlecruisers, *Derfflinger* and *Von der Tann*, who bombarded the Yorkshire seaside town for around half an hour. They fired roughly 500 shells at the castle and town, killing seventeen inhabitants and injuring many more. Buildings across the town suffered structural damage and had windows smashed out. This photo shows the direct hit on the barracks in the castle complex. At the time there was widespread panic as the people thought the bombardment was the beginning of a German invasion on the east coast. (Historic England Archive)

Opposite above: Skipton Castle
During the Civil War Skipton was the last Royalist bastion in the north, yielding only after a three-year siege in 1645. Slighted under the orders of Cromwell, the castle was skilfully restored by the formidable Lady Anne Clifford. Skipton remained the Cliffords' principal seat until 1676. (Historic England Archive)

Opposite below: Scarborough Castle
The headland separating the two bays at Scarborough has evidence of human activity dating back as far as 2000 BC. There is also evidence of an Iron Age settlement, a Roman signal station and a Saxon chapel. The Norman castle that dominates the site now is believed to have begun construction in the late 1130s by William le Gros, and the town grew around this important outpost. (Historic England Archive)

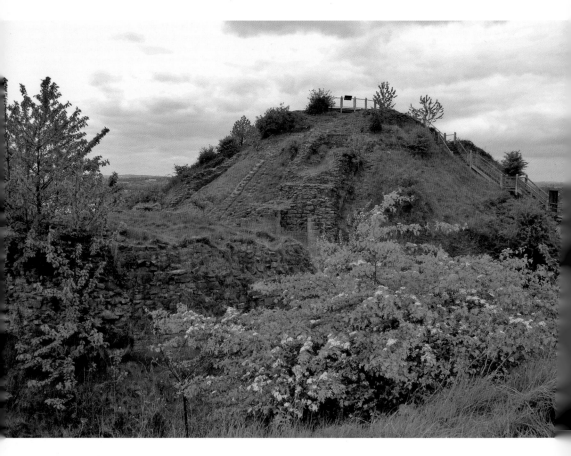

Sandal Castle

Though fortified much earlier, most of what we see today is attributed to John de Warenne, who carried out extensive works around 1230. He enlarged the motte and added a stone keep, extended to the west and built a substantial barbican. The entire complex was surrounded by an extensive and deep ditch. Though almost completely destroyed by the Parliamentarians after the English Civil War, for being used as a Royalist stronghold, Sandal Castle has also had significant roles to play in history. It was involved in the Earl of Lancaster's rebellion against Edward II in 1317, and during the Wars of the Roses the Duke of York was mortally wounded here at the Battle of Wakefield on 30 December 1460. (Author)

Stately Homes

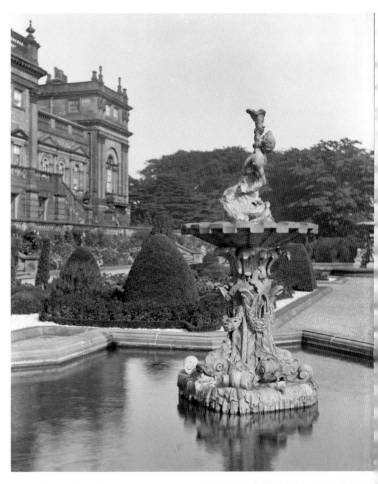

Harewood House
Edwin Lascelles, the wealthy owner of many West Indian plantations, started building Harewood House in 1759. This 'sugar baron' employed some of the finest craftsmen of the time to realise his ideal home, including the prominent architect John Carr, interior designer Robert Adam, fine furniture maker Thomas Chippendale and the renowned landscape gardener Lancelot 'Capability' Brown. This image shows one of the fountains in a star-shaped pool in the formal garden to the south. (Historic England Archive)

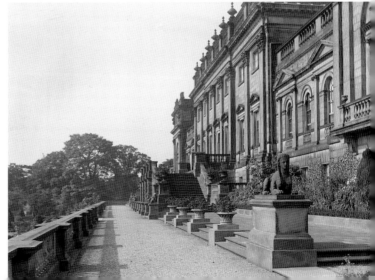

Harewood House
Showing off your wealth and opulence was the order of the day, and the architectural beauty is clearly evidenced by this view along the terrace to the south, showing the south elevation of the house, with a statue of a sphinx on a pedestal in the foreground. (Historic England Archive)

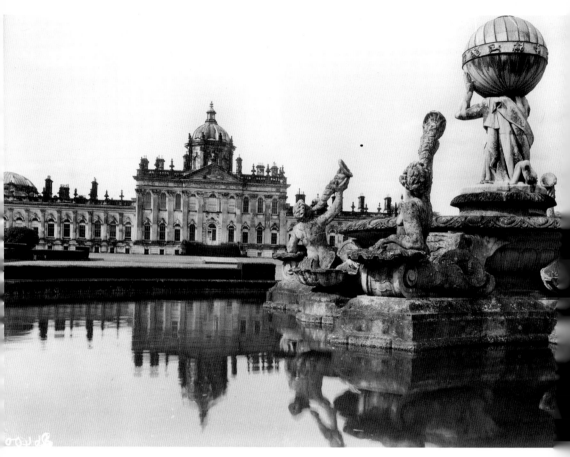

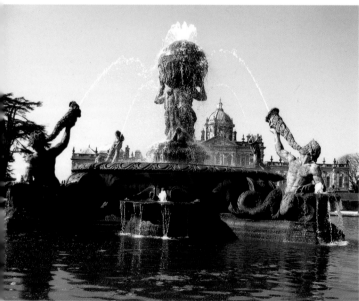

Above and left: Castle Howard
Work actually began on Castle
Howard in 1699, but took over
100 years to complete and spanned
the lifetimes of three earls. It was
the 3rd Earl of Carlisle and his
friend, dramatist John Vanbrugh,
who designed the initial house, but
neither had built anything before
and so enlisted the help of Nicholas
Hawksmoor to oversee the practical
side of design and construction. By
1725 most of the exterior structure
was complete and its interiors
lavishly finished, but unfortunately
Vanbrugh died in 1726 with the
west wing incomplete because
most of the attention had turned
to landscaping the gardens.
(Historic England Archive; Author

Above and below: Castle Howard

When the 3rd Earl died in 1738, the building was still incomplete and his son-in-law Sir Thomas Robinson had the original baroque design replaced by the 4th Earl's conservative Palladian west wing. This gave Castle Howard an unbalanced appearance, which often provoked a mixed and puzzled response as visitors noticed the lack of consistency in the design, which was only compensated by the 1,000 acres of stunning landscaped surroundings. (Author)

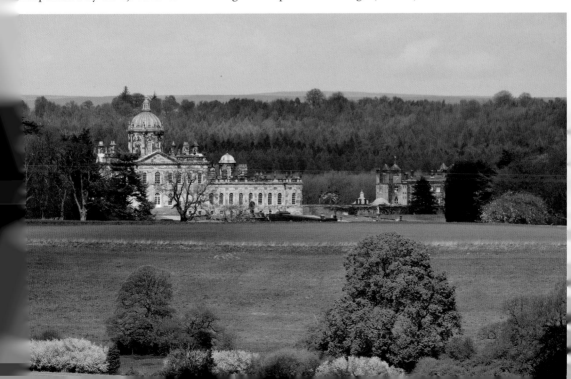

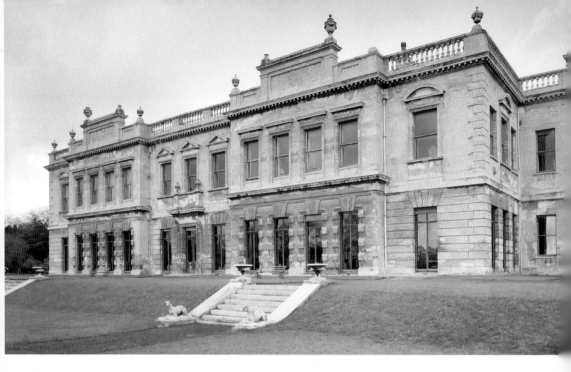

Brodsworth Hall

Located to the north-west of Doncaster, Brodsworth Hall was built between 1861 and 1863 for the Thelluson family, who were descendants of French Huguenots (Protestants) who had escaped persecution in the 1760s. The family had a long tradition in European commerce and finance. As with many stately homes after the First World War, the house fell out of use under the ownership of the Thelluson family and was inherited by Charles Grant-Dalton in 1931. His wife lived at Brodsworth until her death in 1988 when the house and gardens were donated to English Heritage by her daughter. (Historic England Archive)

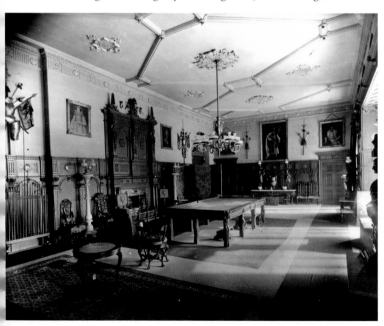

Temple Newsam

Positioned on a much earlier site, Temple Newsam House was built around 1500 by Thomas Lord Darcy, a courtier and crony of Cardinal Wolsey. Originally the house consisted of four ranges set around a larg courtyard, an entrance gateway was in the north wing, a great hall in the south wing and the private apartments in the west wing. Between 1622 and around 1628, the east wing wa demolished and the north and south wings were rebuilt. This photograph shows the interior of the hall with the billiard table and a fireplace in 1894. (Historic England Archive)

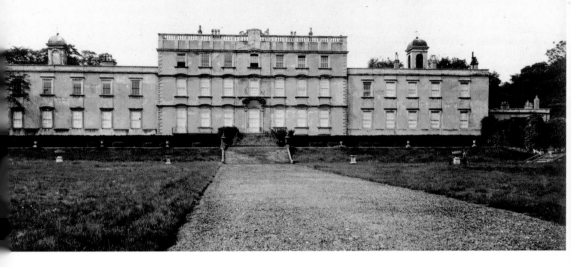

Above: Sprotbrough Hall

Sprotbrough Hall was built in the seventeenth century for Sir Godfrey Copley, a scientist and engineer, and remained in the family until the 1920s. During the First World War, the heir to the estate, Redvers Bewicke-Copley, was killed in action. The hall was sold and demolished soon after the First World War and a housing estate was built on the land. (Historic England Archive)

Below: Grimston Park

The land around Grimston has a long history of occupation and even includes two unexcavated Roman villas on the estate. The land has been owned by the de Lacys, the Vavasours and the Fairfaxes. In the seventeenth century the Stanhope family owned the mansion and entertained James I of England in 1603 on his way to be crowned in London. In 1812 the estate was bought from the Townend family by Sir John Francis Cradock, the 1st Lord Howden, who had been aide-de-camp to the Duke of Wellington. When he died in 1839, his son commissioned the architect Decimus Burton to rebuild the John Carr-designed house at Grimston Park into an Italianate palace for himself and his bride, Princess Catherine Bagration. This view from the south-west of Grimston Park shows the south elevation of the house and the path running through the formal gardens. (Historic England Archive)

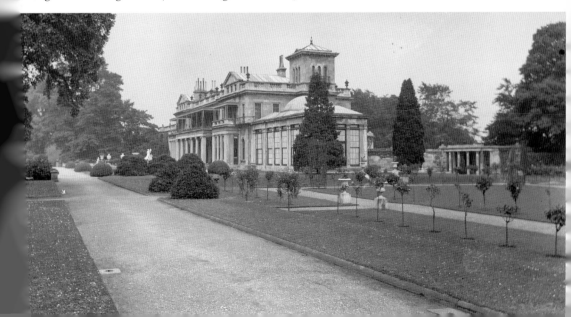

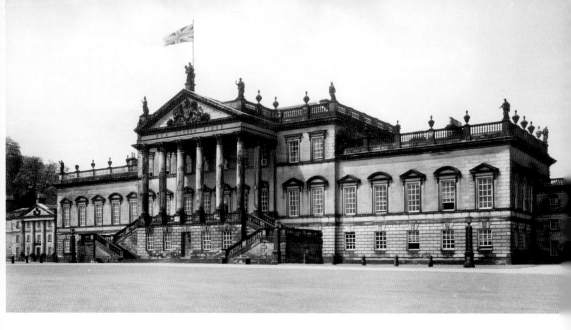

Above: Wentworth Woodhouse

Wentworth was built principally for Thomas Watson-Wentworth, who later became the Marquess of Rockingham, and is considered one of the finest and grandest Georgian houses in England. At 606 feet, Wentworth is understood to have the longest façade of any stately home in the country. (Historic England Archive)

Below: Rokeby Hall

Some landscaping or garden features can be of a more unusual nature. At Rokeby Hall, in what was North Yorkshire, this garden feature consists of five Roman altars collected from local Roman forts at nearby Greta Bridge and possibly from Birdoswald in Cumbria. (Historic England Archive)

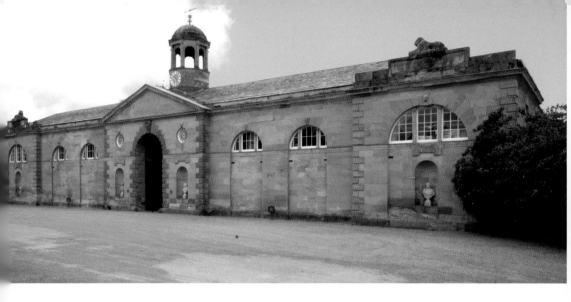

Above: Newby Hall

Some stables were built to be as grand as parts of the house, such as these ornate stables at Newby Hall. William Belwood was Robert Adam's foreman and while carrying out work to the main entrance, Belwood also designed these fine buildings to the north of the house. (© Historic England Archive)

Below: Sledmere Hall

Sledmere Hall is still occupied by the owner, which makes it is less like a museum and more like an intrusion into someone's home. The interior is still as grand, but with a much more homely feel than with the larger charity-owned houses, and because of this it is well worth a visit. (Historic England Archive)

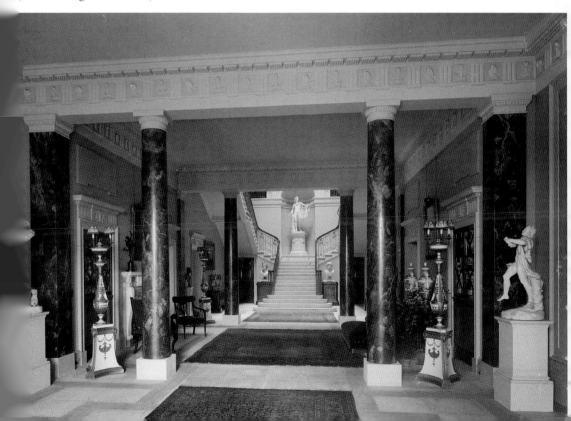

Coastal Towns

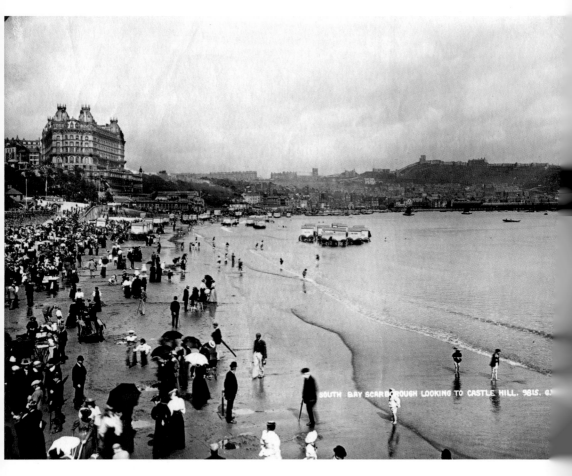

Scarborough
South Sands, Scarborough, filled with hundreds of visitors, some with bathing machine
in the sea. The Grand Hotel can be seen to the left and Castle Hill is in the distanc
(Historic England Archive)

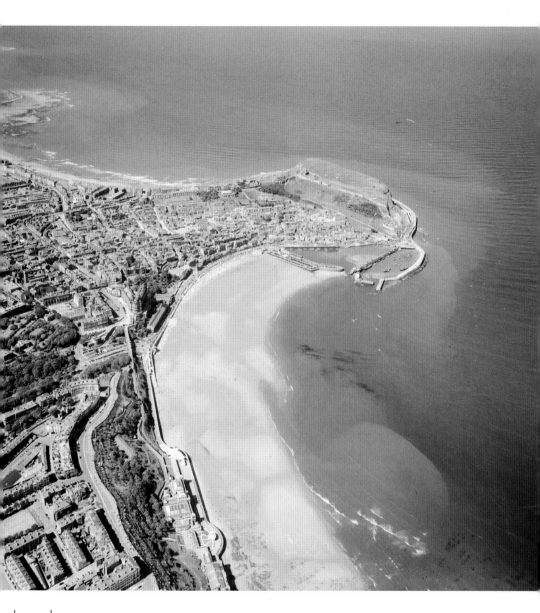

arborough

his is an aerial view of Scarborough taken in 1947 and shows the town centre, North
d South Bay, as well as the prominence of the headland. (© Historic England Archive.
erofilms Collection)

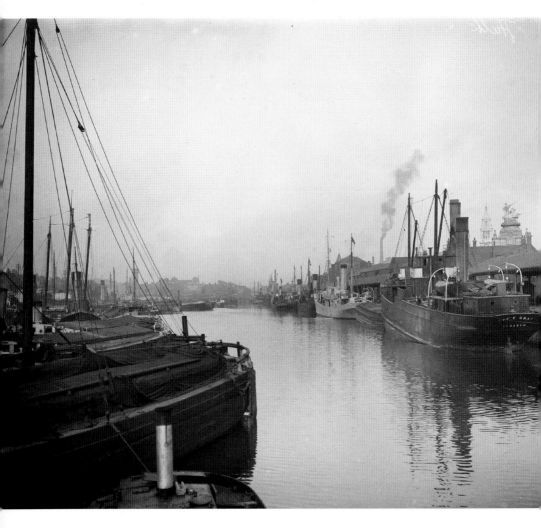

Above: Hull
Hull was always an important port sitting in the shelter of the Humber Estuary. The constructi
of the dock began in 1775 and was opened in 1778. At the time it was the largest dock in t
country and was simply known as 'the Dock'. It was then called the Old Dock until 1854, wh
it was renamed Queen's Dock in honour of the royal visit by Queen Victoria and Prince Albe
The dock was in use until it finally closed in 1930 when it was purchased by Hull Corporati
for £100,000, and over the next four years it was filled in and landscaped to become Quee
Gardens. (Historic England Archive)

Opposite above: Hull
When the first enclosed dock was completed in 1778, its excavation resulted in the remo
of the northern section of the city's defences. It was followed in 1809 by the Humber Do
and the Junction Dock (Prince's Dock) in 1829. This led to the removal of the old city wal
thought to be a barrier to expansion, which allowed the town to spread out without hindran
(© Historic England Archive. Aerofilms Collection)

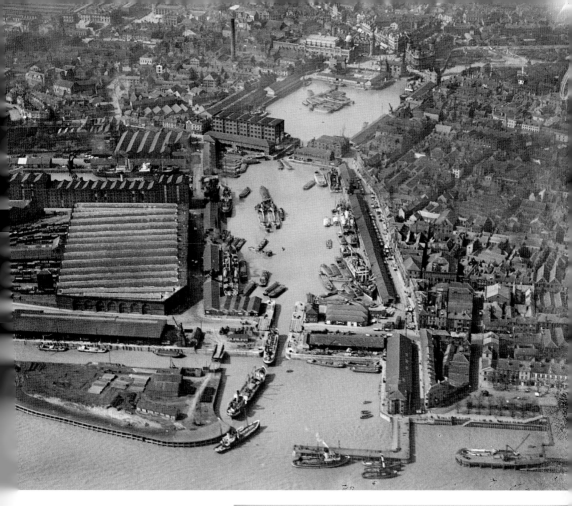

Hull

The importance of Hull as a port was not lost on the Luftwaffe during the Second World War and it was a regular target for German bombers. Over 1,200 people in Hull lost their lives and a further 3,000 were seriously injured. Well over three-quarters of the housing in the city was destroyed or bomb damaged. This image shows the remains of bomb-damaged houses in the High Street, with the tower of Holy Trinity Church in the distance. (Historic England Archive)

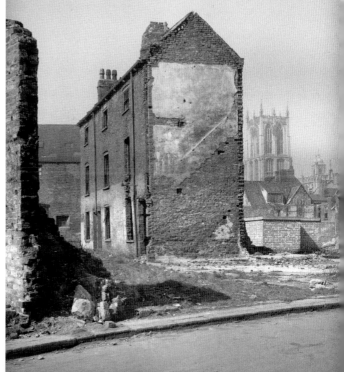

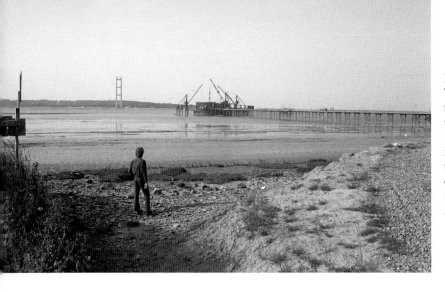

Humber Bridge
The construction of the Humber Bridge was started in July 1972. This image is from 1975 when the bridge was only partially built. (Historic England Archive)

Below left: Humber Bridge
The suspension bridge was finally opened on 24 June 1981 and was 2,220 meters in length, spanning the Humber Estuary. The bridge was the longest single-span suspension bridge in the world for seventeen years. (© Historic England Archive)

Below right: Flamborough Head Lighthouse
The first Flamborough Head Lighthouse was built by Sir John Clayton in 1669, but was never actually lit. The current lighthouse was actually built in 1806 to a design by architect Samuel Wyatt and constructed by John Matson of Bridlington for £8,000. As with most UK lighthouses, it is now automated, with the last keeper leaving in 1996. (© Crown copyright. Historic England Archive)

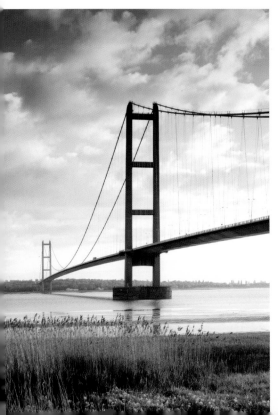

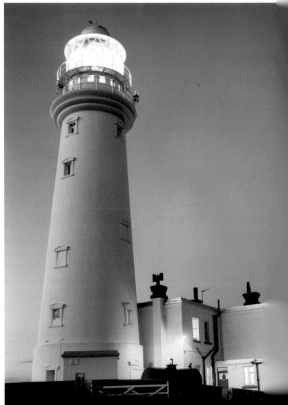

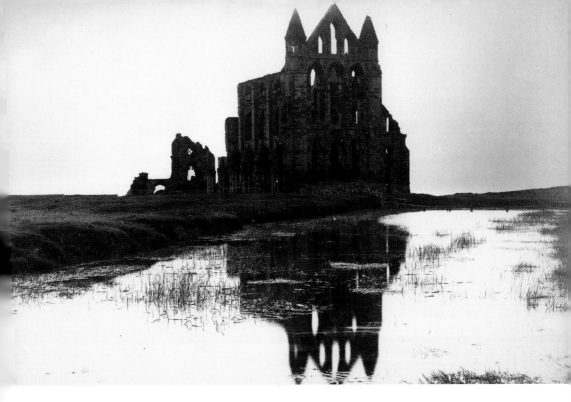

Above and below: Whitby

The seaside town of Whitby is situated on the east coast of the county at the mouth of the River Usk. The famous Whitby Abbey resides on the town's East Cliff. The first monastery here was founded around 657 and became one of the most important Anglo-Saxon religious sites in the country. (Historic England Archive; Author)

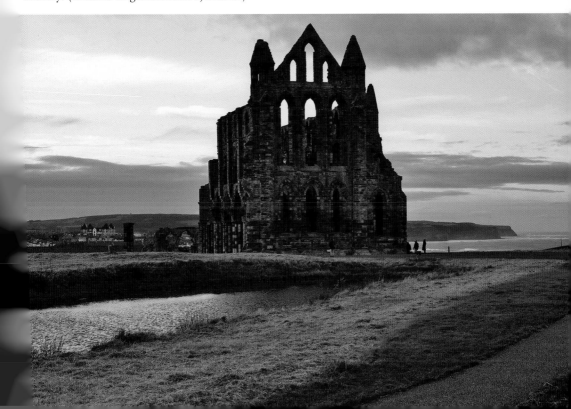

Above and below: Bridlington

Bridlington has a long history, with a church being mentioned in the Domesday Book and, during the Dissolution of the Monasteries, there are mentions of a monastery. In the early Norman period Walter de Gaunt is known to have endowed the Church of St Mary to support canons of the St Augustine Order. A charter from King Stephen gave them 'the port and harbour of Bridlington', and in 1200 he granted them a yearly fair and a market every Saturday. The town grew as a seaside resort during the expansion of the railways, becoming one to compete with Filey and Scarborough. (Historic England Archive)

Staithes

Staithes was once one of the largest fishing ports on the north-east coast and was Captain James Cook's home for a time. Later, Staithes was to become the home of many great artists who revelled in the exceptional light and the characters from the port that they could commit to canvas. (Historic England Archive)

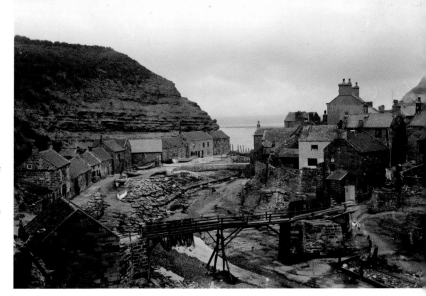

Robin Hood's Bay

It appears that in the sixteenth century Robin Hood's Bay was of greater importance than Whitby, evidenced by a series of Dutch sea charts published in 1586 where Robin Hood's Bay is shown but Whitby is not even mentioned. In the eighteenth century, Robin Hood's Bay was more than a fishing port and was considered the busiest smuggling community on the Yorkshire coast. Its isolated position, protected by marshy moorland on three sides, was a natural aid to this sensitive business, which must have paid better than fishing. (Historic England Archive)

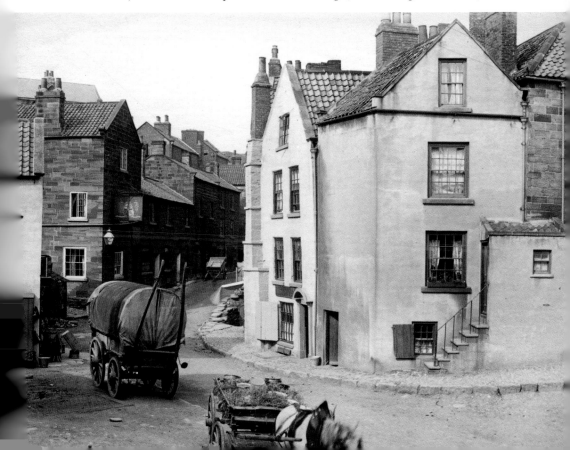

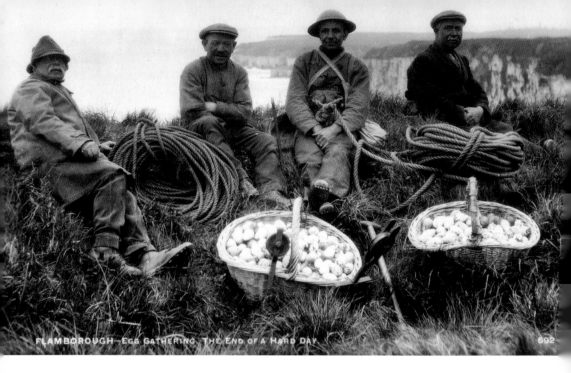

FLAMBOROUGH—EGG GATHERING. THE END OF A HARD DAY. 592

Above: Flamborough Cliffs
One of the more dangerous jobs on the coast was collecting sea birds' eggs from the cliffs.
Here we see four men with ropes and baskets full of eggs after a successful day collecting at
Flamborough. (Historic England Archive)

Below: Hornsea
Hornsea followed the trend as seaside resorts grew in popularity around the early nineteenth
century, and this growth accelerated when the railway line opened in 1864. In 1873, Hornsea
was described as 'the quaintest mixture of a small country town and a callow sea bathing place.
The better half of it is … little more than a marine suburb of Hull'. This photograph shows
Victoria Gardens. (Historic England Archive)

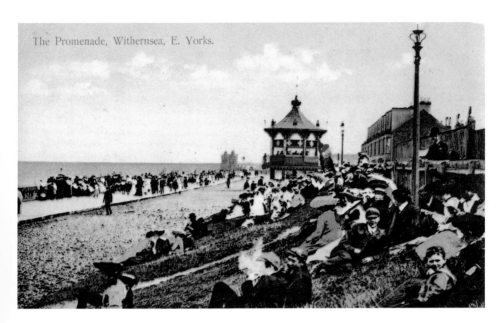

Withernsea

Withernsea was a small village with a population of around 120 until, in 1852, Anthony Bannister proposed building a railway line from Hull and developing Withernsea into a new seaside resort. The railway line between Withernsea and Hull opened on 27 June 1854 and brought families from the industrial town on holiday breaks. (Historic England Archive)

Filey

Filey was only a small village until the mid-nineteenth century, when the Victorians discovered promenading and taking the sea air. In 1835, the Crescent, a row of fine domestic terraces, was built and in 1850 the Royal Crescent Hotel opened its doors, helping Filey compete with the larger neighbouring seaside towns. Filey became the home of Butlin's Holiday Camp in 1939, which for more than forty years was part of the quintessential British seaside holiday, until it closed in 1984. The photograph shows Filey Brigg in 1894. (Historic England Archive)

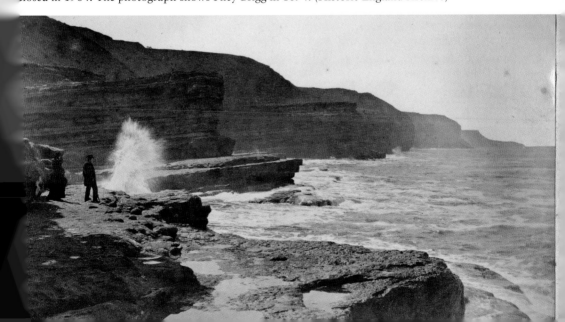

Industry

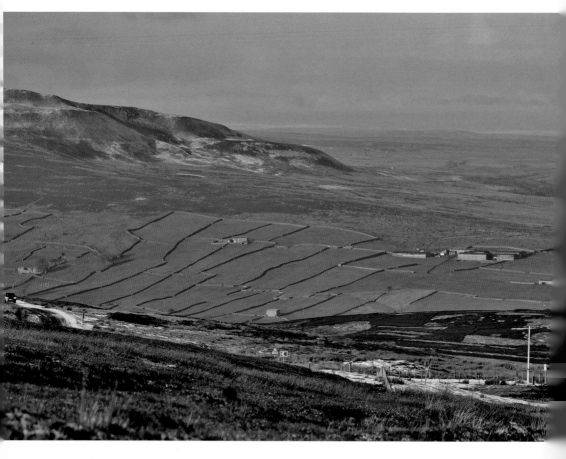

Above: Swaledale
Swaledale may not look like an industrial landscape, but at various times throughout history this area was the largest producer of lead in the country. This industry dates from before the Romans exploited the dale in the second, third and fourth centuries AD. (Author)

Opposite below: Halifax
In 1868 John Crossley & Sons was the largest publicly quoted industrial company in Britain with an ordinary share capitalisation of £2.2 million (around £220 million in current terms) and approximately 5,000 employees. The population of Halifax in 1901 was 104,936 and nowadays is only around 90,000. This image shows Halifax from the air in 1938, showing the intensity of industry in the town at the time. (© Historic England Archive. Aerofilms Collection)

Right: Halifax

West Yorkshire had all the ingredients to be successful during the Industrial Revolution, with coal, sheep and fast-flowing rivers for mill wheels in abundance. These were followed by the opening of the Leeds and Liverpool Canal in 1816 and the railways from the 1840s. The growth of the mills and the rapid increase in wealth left a real impact on the surrounding towns and cities. This photograph was taken looking along the cobbles of Boys Lane in Halifax, past the former Shaw Lodge worsted mill, towards the mill chimney in the distance. (Historic England Archive)

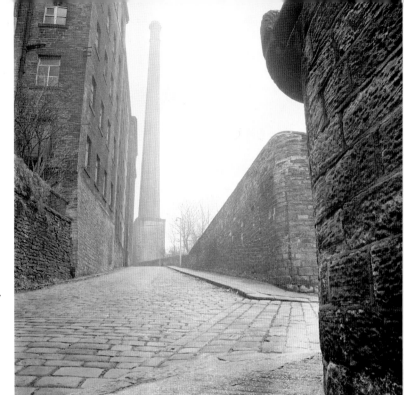

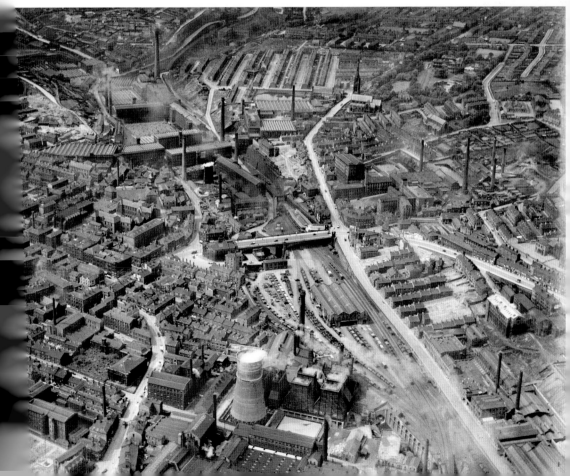

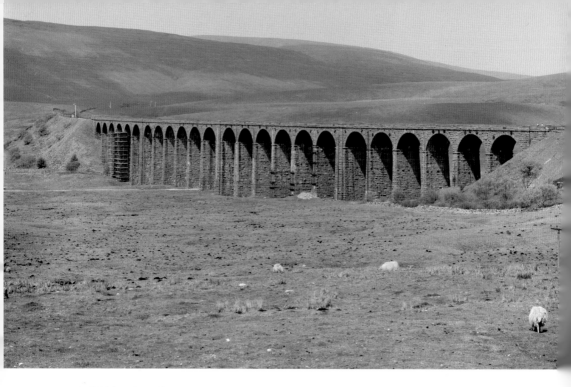

Ribblehead Viaduct

The first stone on the Ribblehead Viaduct was laid in October 1870 and at the peak of its construction employed around 2,000 men. Many men died during the four years it took to complete – it may have run into the hundreds, which would not be acceptable today. Opening in 1875, the viaduct further increased the rail network and has become an iconic symbol of Yorkshire. (Historic England Archive)

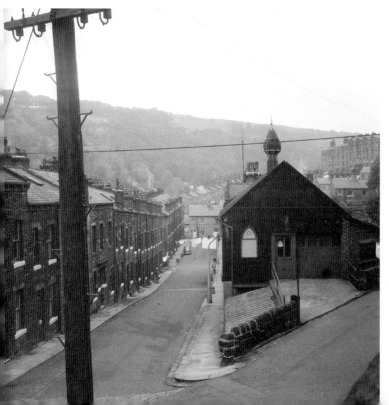

Hebden Bridge
With the rapid increase of industry came the need for workers' housing and their spiritual upkeep. This is a view looking along Unity Street in Hebden Bridge with the hastily built Wesleyan Mission 'Tin Tabernacle' in the right foreground.
(© Historic England Archive)

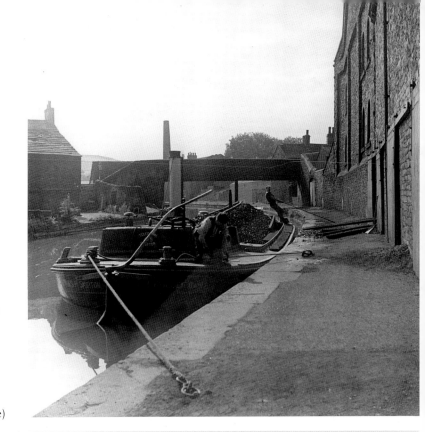

Skipton
A coal barge on the Leeds
and Liverpool Canal at
Skipton. For a few years
the canals were essential
for the transport of raw
materials and goods to
the port of Liverpool.
(Historic England Archive)

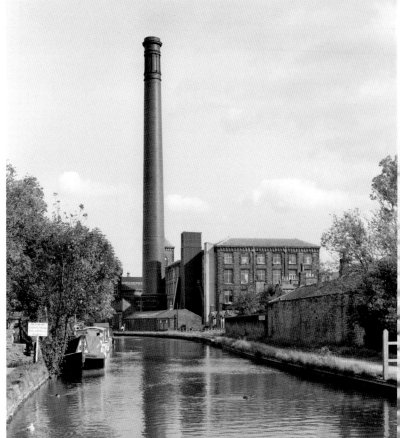

Skipton
A view taken looking
east along the Leeds and
Liverpool Canal towards
Belle Vue Mills, Broughton
Road, Skipton. The Belle
Vue Mill was established
in 1828 as a multistoreyed
steam-powered worsted
spinning and weaving mill.
This was burnt down on
January 1831 and the
mill was rebuilt as a cotton
spinning mill. The English
Cotton Company took
over in 1898 and produced
a special product called
Sylko Cotton thread. The
thread was manufactured
in over 500 shades.
(Historic England Archive)

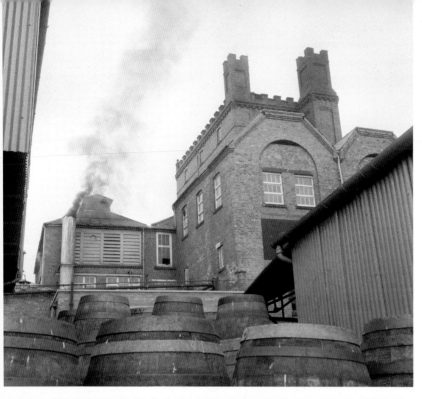

Tadcaster
All this industry was thirsty work, so breweries needed to industrialise. This is the Tower Brewery at Tadcaster on Wetherby Road, showing barrels stored in the brewery yard. The brewery was founded by John Smith at Tadcaster in 1847, and by 1852 the local markets expanded due to the increase of industry in the West Riding. Today the brewery produces in excess of 3 million barrels of beer per year. (© Historic England Archive)

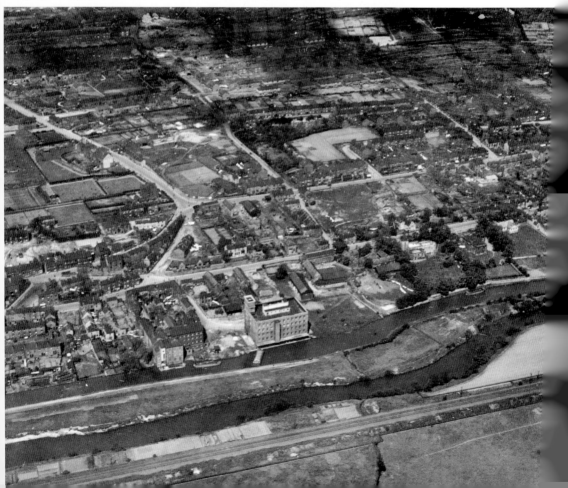

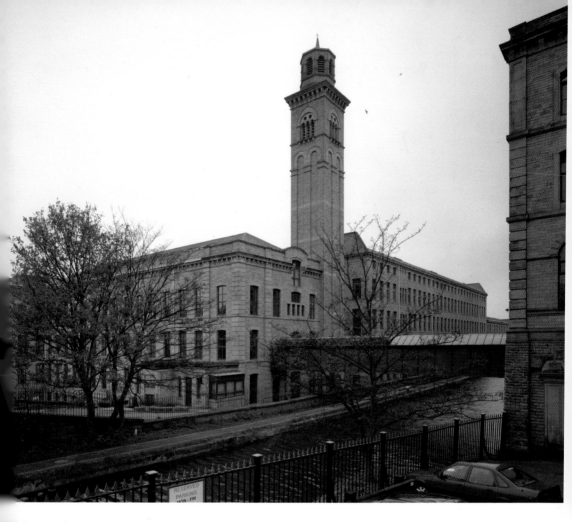

Above: Saltaire

The village of Saltaire was built in 1851 by Sir Titus Salt, a leading industrialist in the Yorkshire woollen industry and a man who recognised the need for social reform. The living and working conditions of the workers was horrendous, with pollution from the mills shrouding Bradford with choking smog. Sanitation was atrocious too, infant mortality was high and life expectancy was short, especially with the recent bouts of cholera in the country. Saltaire would look after the body and mind of his workers, which it was hoped would increase efficiency and productivity. This photograph is of New Mill, Saltaire, from across the Leeds and Liverpool Canal. (© Historic England Archive)

Opposite below: Mexborough

Mexborough is actually an ancient town and may have existed at the time of the Roman invasion. There is also the remains of an earthwork in Castle Park believed to have been an early Norman motte-and-bailey castle. The real growth of the town came with the development of industry in the eighteenth, nineteenth and twentieth centuries, based on coal mining, quarrying, brickworks and the production of ceramics. (© Historic England Archive. Aerofilms Collection)

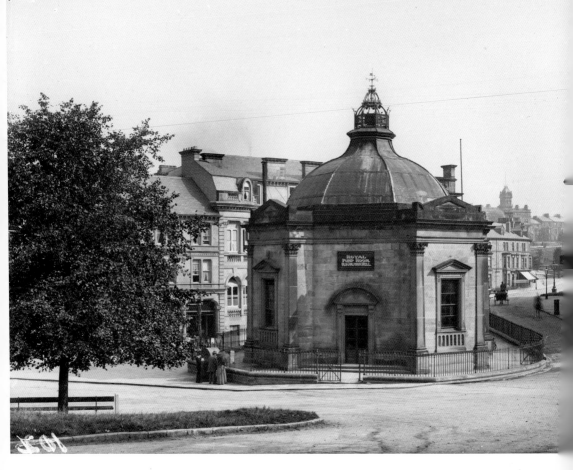

Harrogate

To accommodate the growing middle classes the spa town of Harrogate expanded during the late Georgian and Victorian periods. Harrogate became very fashionable to visit between May and September each year, when the rich, famous and aristocratic would gather in the town to take the waters and to take walks in the gardens. Visitors came to bathe and drink here after doctors wrote about Harrogate waters having the ability to cure medical problems. Public bathing houses sprang up around the town and hoteliers, along with other businessmen, began to offer other services such as Turkish baths. (Historic England Archive)

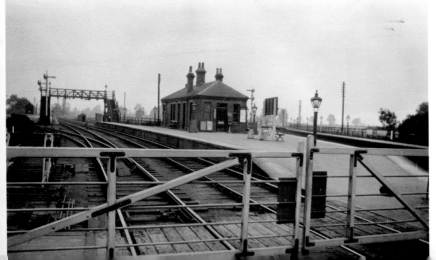

Melmerby Station

The level crossing at Melmerby station can be seen towards the footbridge over the track. The image shows the station building and platform, with the crossing gates in the foreground. (Historic England Archive)

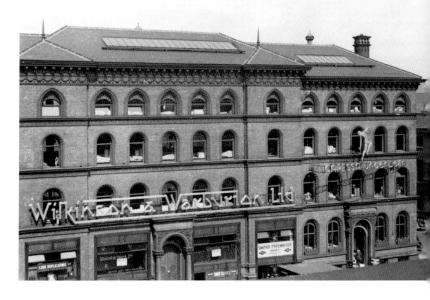

Leeds
The Wilkinson and
Warburton warehouse
on King Street in Leeds.
(Historic England
Archive)

Leeds

The city of Leeds originated as a market town and was known as a cloth-finishing centre after domestic weaving had been introduced by fourteenth-century Flemish weavers. By the sixteenth century Leeds was able to challenge the supremacy of York and Beverley in the wool-manufacturing trade. It was the Industrial Revolution that really shaped Leeds, particularly with the development of the local coalfields and the completion of the Leeds and Liverpool Canal in 1816, which really stimulated the city's growth. Brand-new buildings were built to reflect this wealth, including the Corn Exchange, which was built between 1861 and 1863. (Historic England Archive)

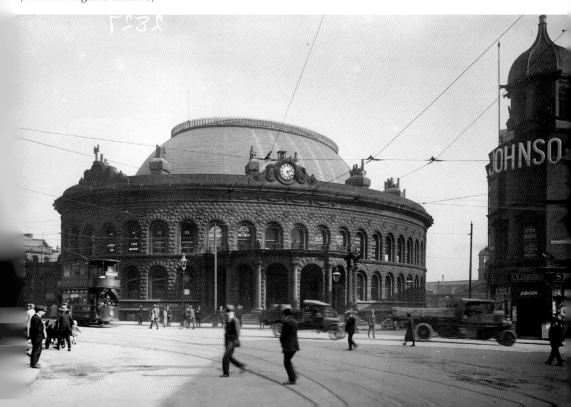

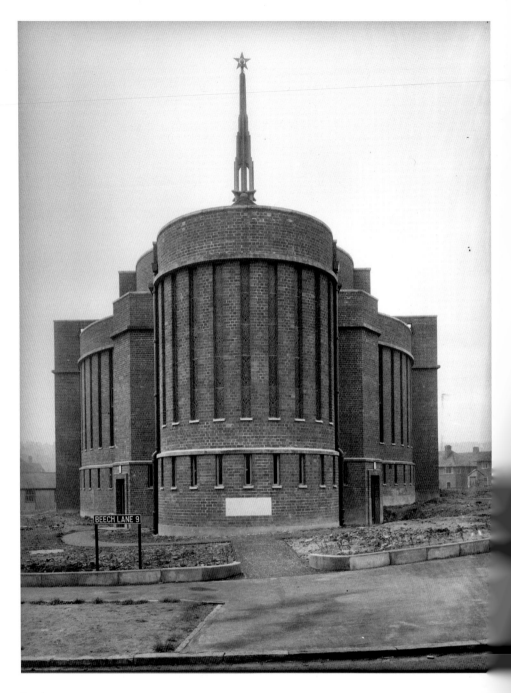

Leeds

This photograph from 1938 is of the newly built Church of the Epiphany, Beech Lane, Gipton, Leeds. This unusual-looking church was designed by N. F. Cachemaille Day and built by Armitage Hodgson of Leeds in reinforced concrete with brick cladding and a plain tile roof. The Gipton estate was one of the first 'garden' estates in the north of England, following the city-centre slum clearance that took place during the 1930s. (Historic England Archive)

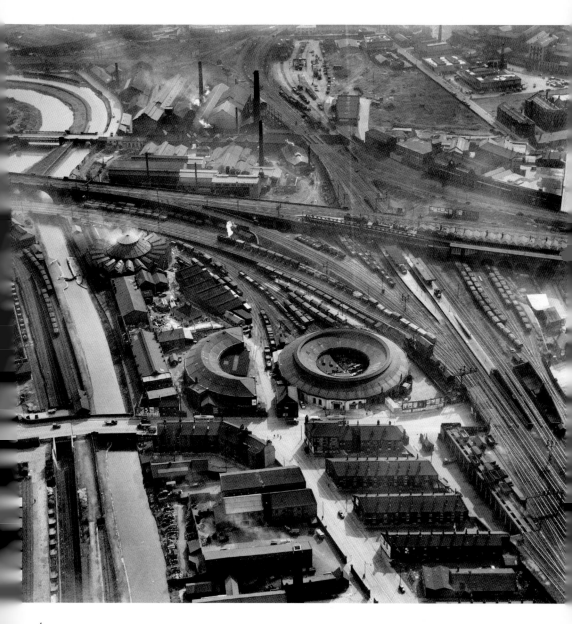

Leeds
The coming of the railway in 1848 saw the city grow further and the end of the nineteenth century saw a massive expansion of the factory production of ready-made clothing, drawing labour from an influx of Jewish immigrants into the city. This image shows the Roundhouse and Half Roundhouse warehouses alongside Holbeck Railway Junction in Leeds in 1946. (© Historic England Archive. Aerofilms Collection)

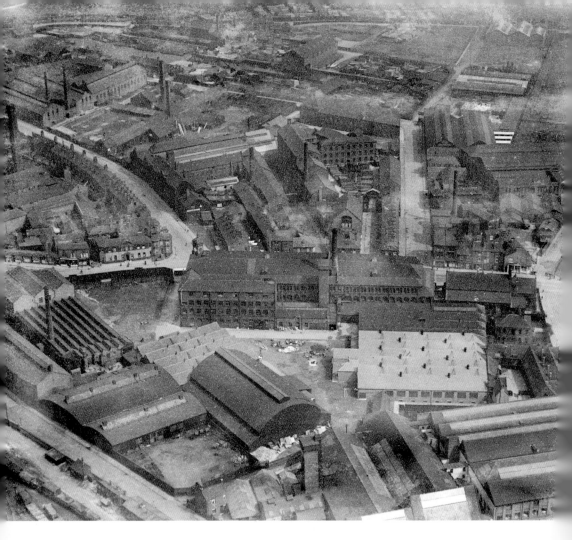

Above: Leeds
Having been rebuilt twice due to fire, Alfred Cooke's New Crown Point Printing Works in Leeds is shown on this aerial view from 1930. At its height in 1895 it was the largest printing works in the world. (© Historic England Archive. Aerofilms Collection)

Opposite above: Bradford
Bradford grew in size at the same time as Leeds due to industrialists like Titus Salt. Sir Titus Salt (1803–76) was a successful businessman who tried to improve the conditions for his workforce by building a model factory and village in Saltaire. He was profoundly influenced by his Methodist faith, which brought a social conscience to his capitalism at a time when many of the nation's industrial workers lived in abject poverty. This is the Sir Titus Salt Memorial in Manningham Park. (Historic England Archive)

Opposite below: Bradford
There has been a mill on the site of Manningham Mills since 1838, but the one seen here was rebuilt after a fire in 1871 and extended in the 1880s. It became the largest silk spinning and manufacturing mill in Britain, producing silks and velvets, and at its peak employed 5,000 people. The mill was also known as Lister Mill after the Cunliffe-Lister family, the owners. (Historic England Archive)

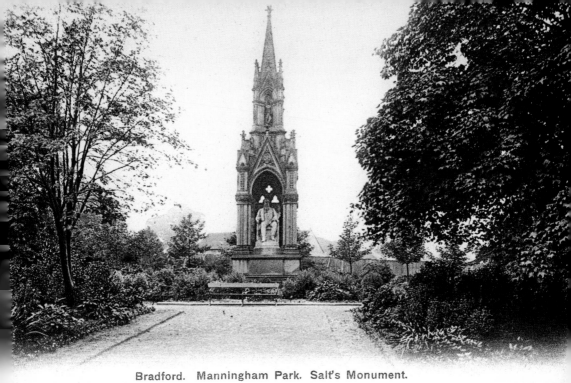

Bradford. Manningham Park. Salt's Monument.

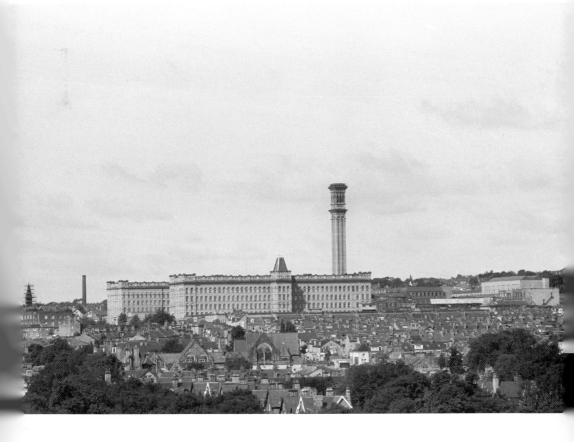

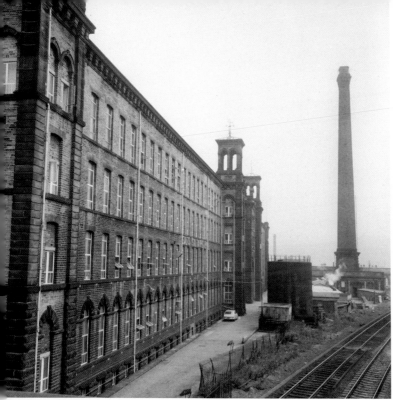

Left: Bradford
This is Salts Mill, seen from the road bridge carrying Victoria Road over the Leeds and Bradford Extension Railway line. (© Historic England Archive)

Below: Bradford
The Lister Park Gateway at Manningham Park. Recreational space and promenading were considered important to the welfare and constitution of the population. (Historic England Archive)

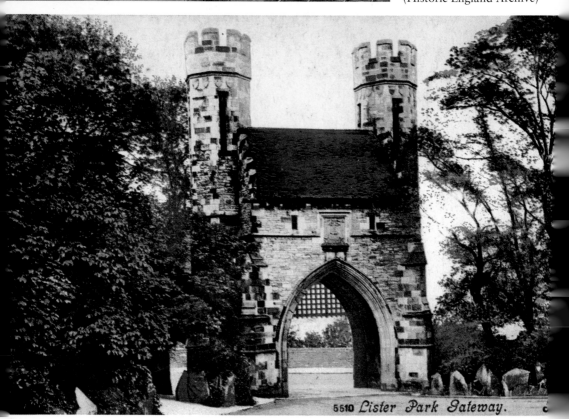

5510 *Lister Park Gateway.*

Right: Bradford
The entrance to Manningham Mills from Heaton Road. The mills were extravagant examples of the wealth of the owner; more and more frequently they were being built to impress as well as be a functional workplace. (© Crown copyright. Historic England Archive)

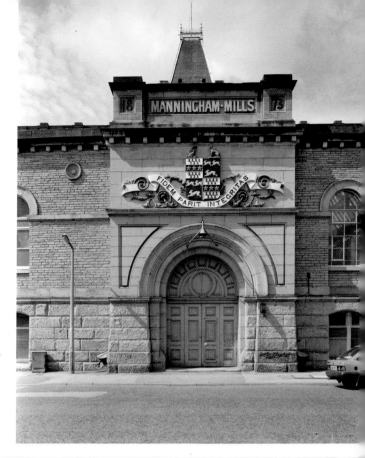

Below: Sheffield
The Blackburn Meadows Power Station at Tinsley, between Sheffield and Rotherham, was once a common site from the M1. In this photograph from 1947 the motorway is not yet built. The towers no longer stand as they were demolished in 2008. (© Historic England Archive. Aerofilms Collection)

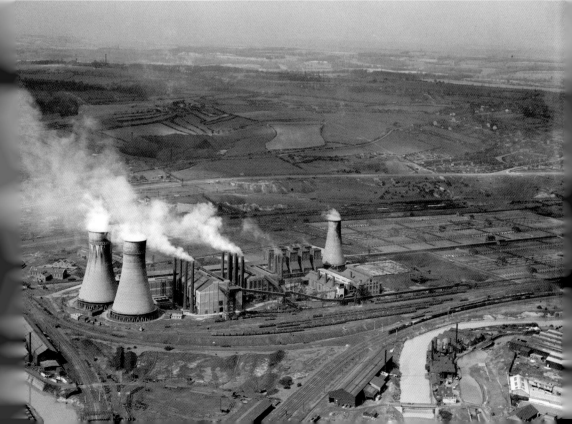

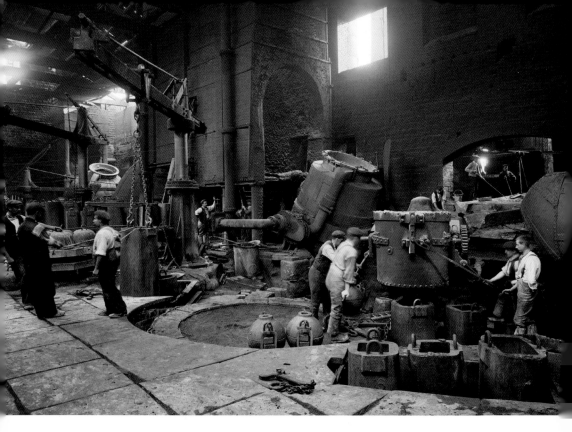

Sheffield
The city of Sheffield is synonymous with metalworking and evidence of cutlery production here dates back more than 700 years. It is the city's location that provided it with the necessary raw materials for the industry, and its fast-flowing rivers provided the water power. By 1600 Sheffield was the main town in England (apart from London) for cutlery production. (Historic England Archive)

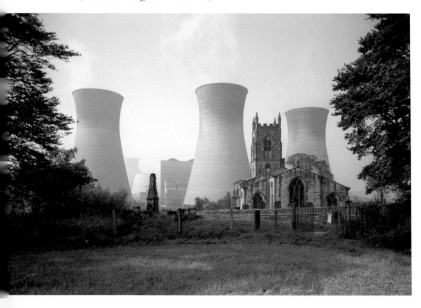

Ferrybridge
With great industry comes a need for power, and Yorkshire had a large number of huge power stations to meet the demand. This image shows Ferrybridge Power Station with St Edward the Confessor's Church in the foreground and cooling towers behind. (Historic England Archive)

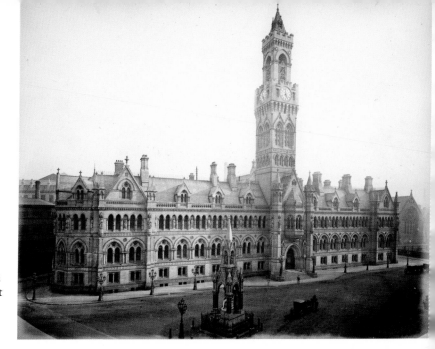

Bradford
Reflecting the wealth of the area, the civic buildings were like palaces and dominated the town centre. Bradford Town Hall is a fine example of the Victorian grandeur, seen here with the monument to Titus Salt in the foreground. (Historic England Archive)

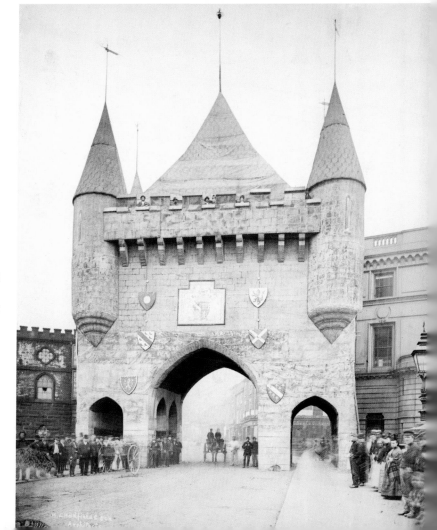

Sheffield Arch
The triumphal arch erected at Lady's Bridge in Sheffield for the royal visit of 1875. The royal procession passed under the triumphal arch erected by the Duke of Norfolk for the visit of Albert and Alexandra, Prince and Princess of Wales (later Edward VII and Queen Alexandra), on 16 August 1875. (Historic England Archive)

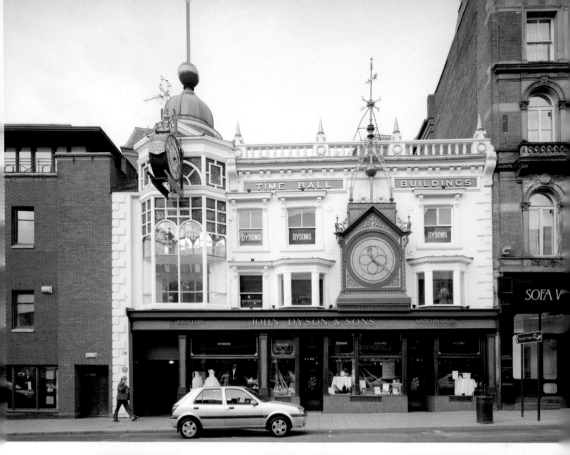

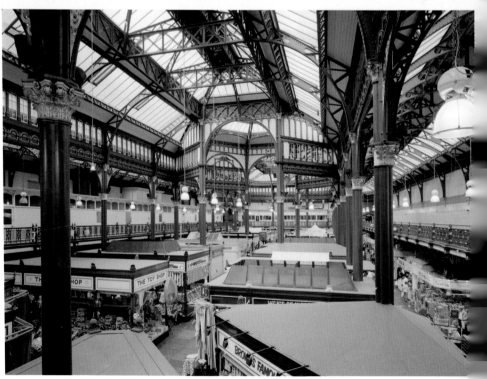

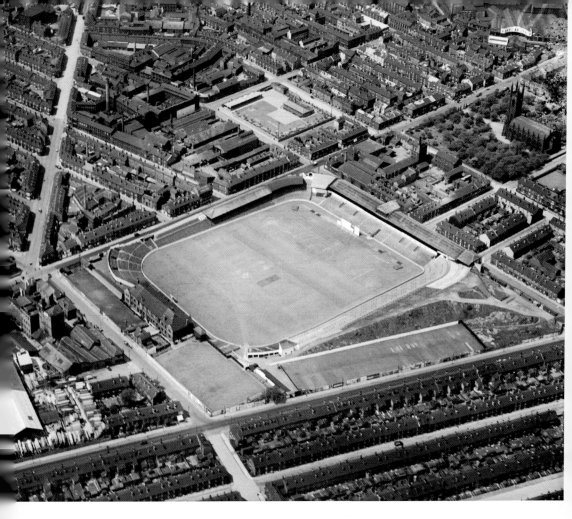

Above: Brammall Lane Football Ground
In the late 1800s football grew as a sport, especially among the working class, and attendances increased significantly. The clubs began to build larger grounds close to the homes of the fans to accommodate the swelling numbers. Sheffield Football Club, founded in 1857, is reputedly the world's oldest surviving independent football club. This photograph is of Sheffield United's Bramall Lane Ground in 1933. (© Historic England Archive. Aerofilms Collection)

Opposite above: Leeds
John Dyson & Sons was established in 1865 and they installed a large clock on the outside of the building. It remains a Leeds landmark to this day. (© Historic England Archive)

Opposite below: Leeds Market Hall
An interior view of Leeds Market Hall, built in 1904. (© Historic England Archive)

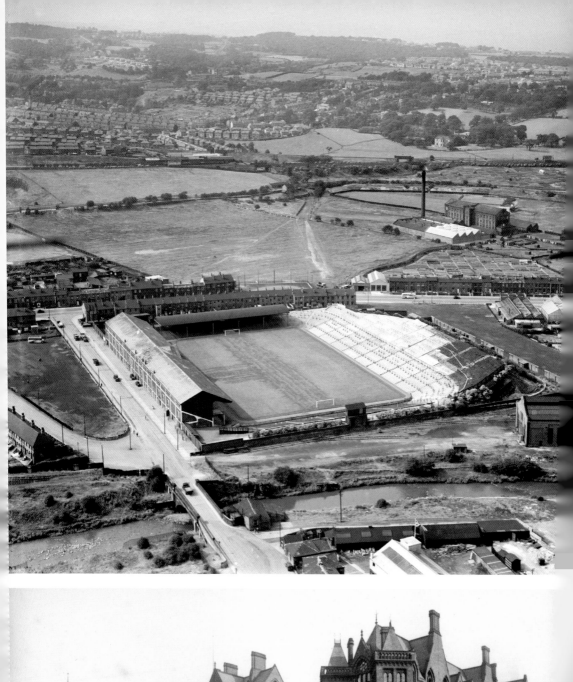

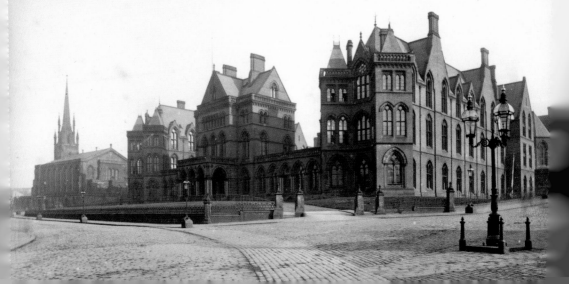

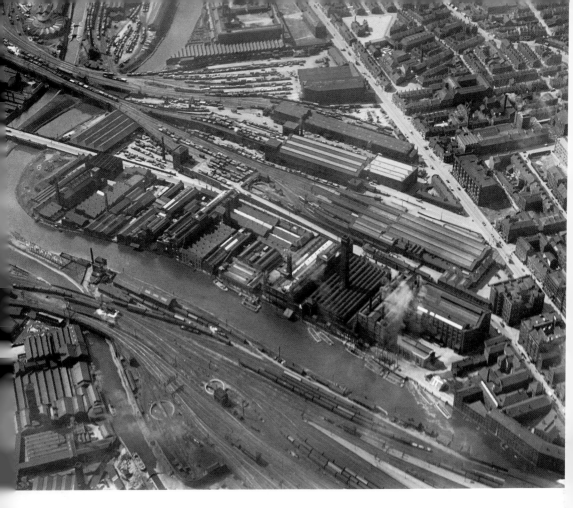

Above: Leeds
The Whitehall Soap Works in Leeds from 1926. The Leeds firm of Joseph Watson & Sons Ltd was founded in 1830 and expanded in 1861 to a site west of the canal basin, between Whitehall Road and the river. Employing around 750 people at its peak, this was one of the largest soap works in England, manufacturing 600 tons of soap a week in 1893. (© Historic England Archive. Aerofilms Collection)

Opposite above: Huddersfield
As football grew, every town formed a team until football became a professional sport in 1885, with the very first league being contested by just twelve clubs in 1888. This is the old Leeds Road Football Ground of Huddersfield Town FC in 1949. (© Historic England Archive. Aerofilms Collection)

Opposite below: Leeds Infirmary
As medical knowledge increased, especially in the Victorian period, great hospitals were built to deal with the healthcare of the city's population. This photograph shows Leeds Infirmary viewed from Great George Street, with gas lamps in the foreground. (Historic England Archive)

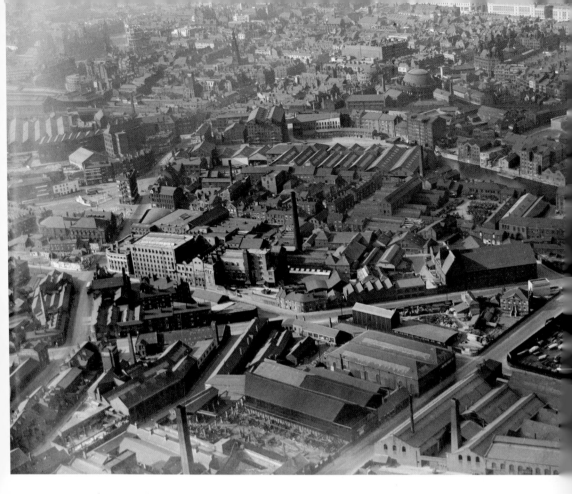

Above: Leeds

Joshua Tetley founded his brewery in 1822 when they acquired William Sykes' brewery. The brewery became part of Allied Breweries, but in January 1993 was renamed Carlsberg-Tetley as a result of an amalgamation with the Carlsberg Brewery. It remained as such until 1998 when the Danish brewer took over the company. This image shows Joshua Tetley Ltd, brewers in Leeds from 1933. (© Historic England Archive. Aerofilms Collection)

Opposite above: Leeds

The Leeds Civic Hall was completed six months ahead of schedule and opened by George and Queen Mary on 23 August 1933. (© Historic England Archive. Aerofilms Collection)

Opposite below: York

York was known for its confectionary manufacturers like Rowntree's and Terry's. In 192 Terry's moved to a purpose-built factory off Bishopthorpe Road. It was here that some famou brands were created such as Terry's All Gold, which was first produced in 1930, and Terry Chocolate Orange just a year later. The racecourse can be seen in the background. (© Histor England Archive. Aerofilms Collection)

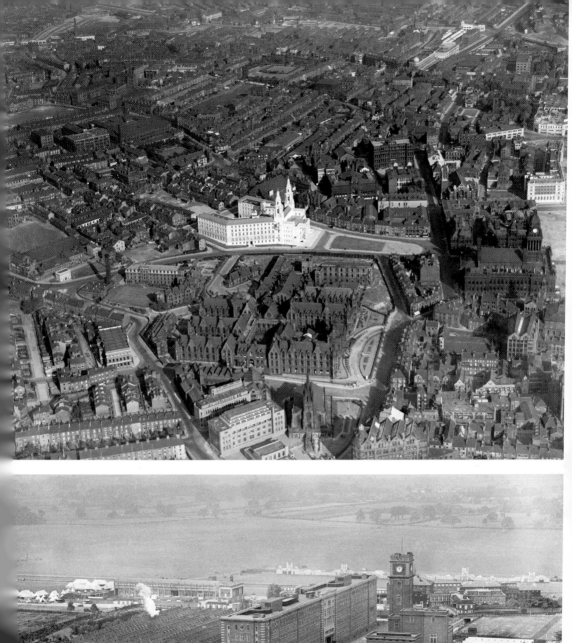

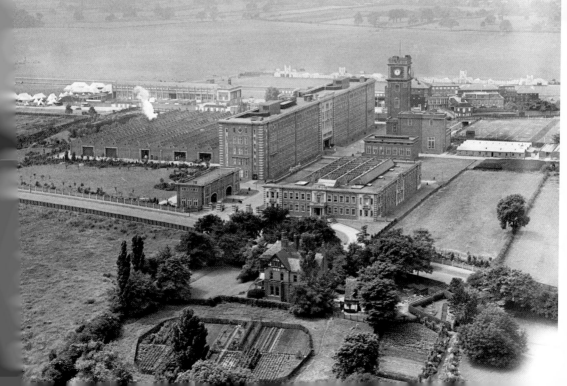

Above: York

Racing in York was transferred to the Knavesmire in 1730 because the course at Clifton Ings was prone to flooding. The Knavesmire, damp wetland (or mire) with a stream running through it, took a substantial amount of levelling and draining to create the first course. It was not until 1754 that the first building was erected there: a grandstand designed and built by the well-known York architect John Carr. (Author)

Opposite above: Barnsley

Barnsley is actually mentioned in the Domesday Book and in 1249 it was granted a charter to hold a weekly market and an annual fair. However, it was during the late eighteenth century, as industrialisation and the need for coal grew, that the town grew exponentially. The Town Hall was built in 1932 and was opened by Edward, Prince of Wales, on 14 December 1933. This aerial photo shows the Town Hall and town centre in 1937. (© Historic England Archive. Aerofilms Collection)

Opposite below: Hawes

Built in 1784, Gayle Mill in Hawes started life as a cotton mill before changing to flax and then wool. In 1879, the mill changed to become a mechanised sawmill and continued to work as such until 1988. The mill fell into disrepair until it was restored in 2008; after four years' hard work it opened to the public. (© Crown copyright. Historic England Archive)

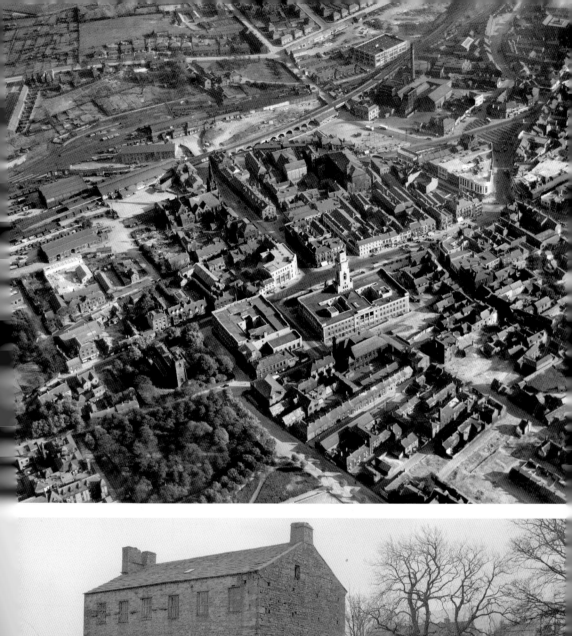

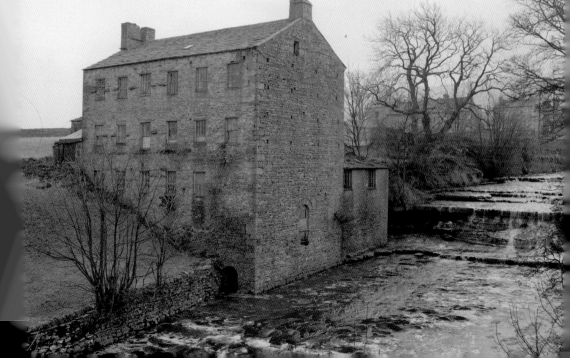

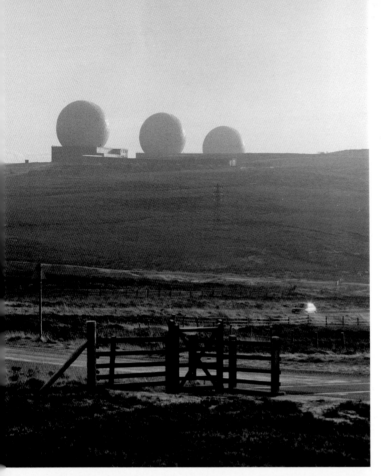

Left: RAF Fylingdales
The country's defence and early warning systems still remain in Yorkshire. These 'golf balls' in the middle of Goathland Moor at RAF Fylingdales have now been replaced with a mysterious, dark, triangular radar system. (© Crown copyright. Historic England Archive)

Below: RAF Menwith Hill
Just above Harrogate is another base. RAF Menwith Hill has geodesic domes that are clearly visible from the surrounding countryside. Built in 1954 and occupied by the US, Menwith claims to be the world's biggest electronic monitoring station, intercepting communications to gather intelligence for the UK and the US. (© Historic England Archive)

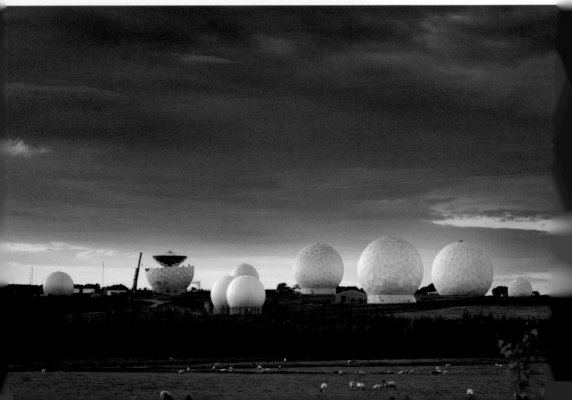

Towns and Villages of Yorkshire

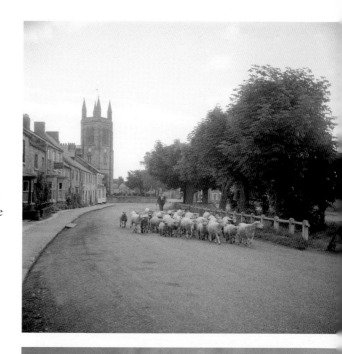

Helmsley
Dominated by the castle, Helmsley is a picturesque village established around a market square. In 1689, Sir Charles Duncombe, a London banker, bought the Helmsley estate and abandoned the castle complex to build a new house. Duncombe Park was built in 1713 away from the castle, which was by then a romantic ruin, and surrounded by landscaped countryside and follies. This photograph is of a shepherd herding a flock of sheep along the street in Helmsley with All Saints Church visible in the background. (Historic England Archive)

everley
1 1293, the archbishop claimed to hold markets in Beverley on Wednesdays and aturdays. The old market cross was eplaced in 1714 by the rather grand ne now standing majestically in the arketplace. (Author)

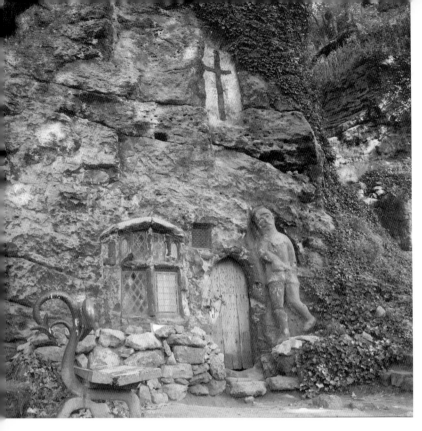

Knaresborough
The Chapel of Our Lady of the Crag is a wayside shrine hewn out of the rock of the cliff face and includes various carvings throughout. The chapel was built in 1408 along the route to Knaresborough Priory, which was destroyed at the time of the Reformation. It is now located off the picturesque path following the River Nidd below the castle. (© Historic England Archive)

Harrogate
The spa town of Harrogate's development included gardens and walks to enhance the town's reputation. This is an elevated view across Prospect Gardens around the early 1900s. (Historic England Archive)

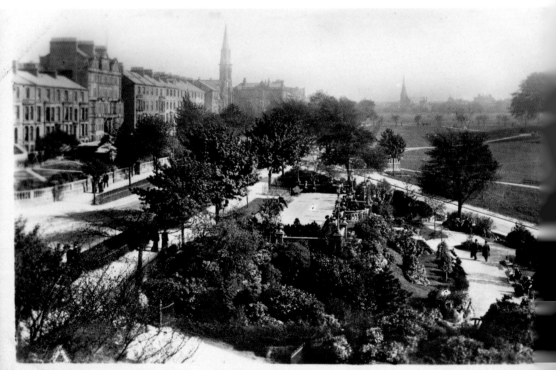

PROSPECT PLACE, HARROGATE

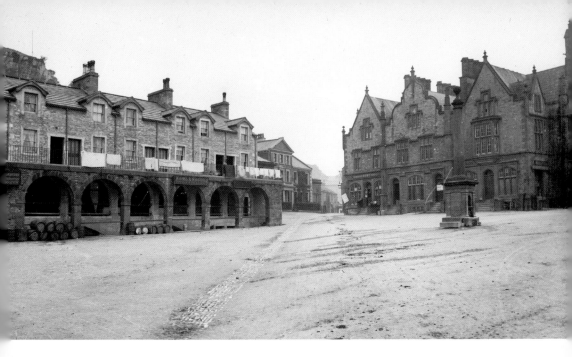

Above: Settle

Thought to date back to the seventh century, Settle obtained its first charter in 1249 when Henry de Percy (1228–72) petitioned Henry III. This photograph, taken in 1891, shows the Settle drinking fountain, the Shambles and Town Hall in the Market Place. (Historic England Archive)

Below: Keld

The Yorkshire Dales have long been an Area of Outstanding Natural Beauty. Though considered natural, they are a product of nature and man's prolonged reshaping of the landscape through farming and industry. (Author)

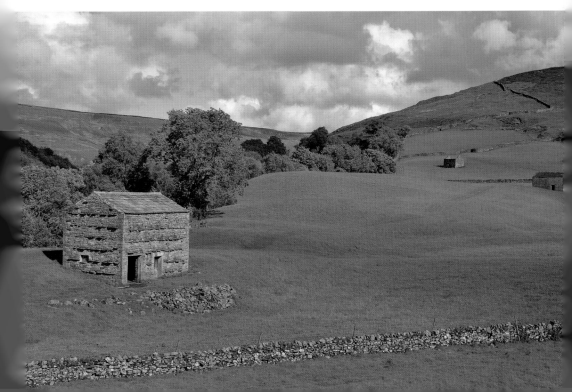

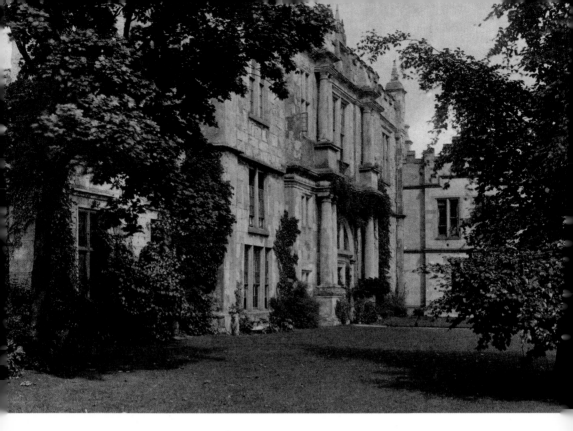

Malton

Malton dates back to at least the first century AD, when it was occupied by the Roman fort of Derventio on the north bank of the River Derwent. Around the fort a large civilian settlement grew up and expanded until the Romans left in the fifth century. The next occupiers – the Normans – built a timber castle in the eleventh century, which had been rebuilt in stone by the time of Richard the Lionheart, who visited the castle in 1189. The castle was inherited by Lord William Eure in 1544, but the time of castles was over and a more opulent abode was required. Subsequent lords built a grand house on the site, but in 1674 this was demolished. All that remains of it is the Old Lodge, a reminder of the grand building that once stood here. (Historic England Archive)

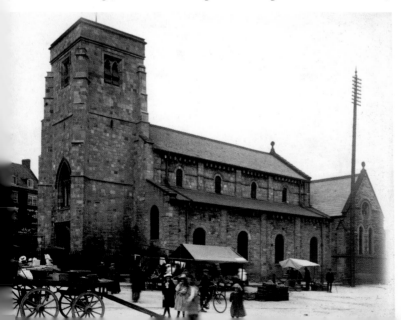

Malton
St Michael's Church in Malton dates from the mid-twelfth century but, as with most churches, it has been significantly modified over the years. The tower was built in the fifteenth century and further works were carried out in 1858 and 1883. (Historic England Archive)

Above and below: Sutton Bank
The views from Sutton Bank escarpment looking over the Vale of Mowbray and the Vale of York are spectacular. (Author)

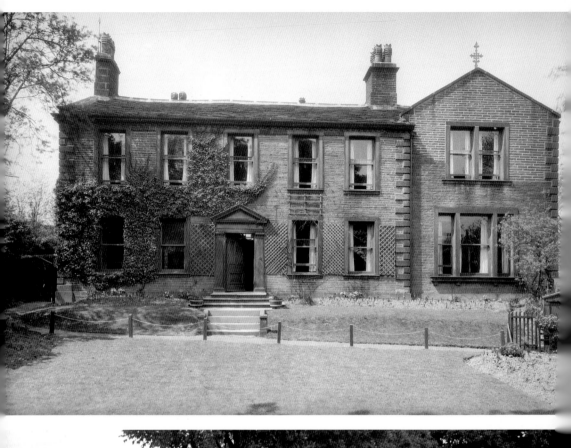

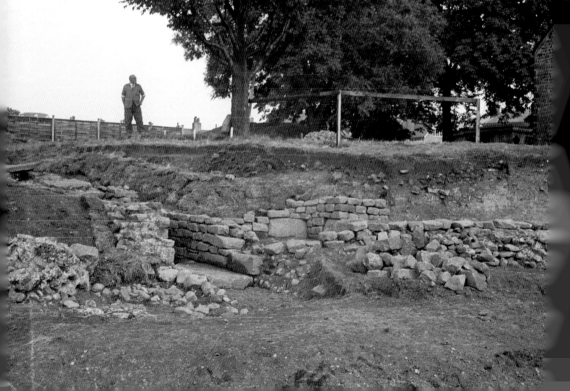

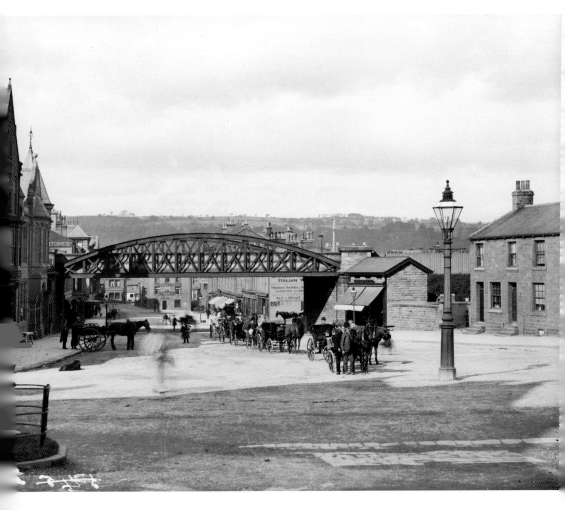

Above: Ilkley
This is a view looking north along Brook Street, showing the railway bridge and a line of horse-drawn vehicles queuing in the road. (Historic England Archive)

Opposite above: Haworth
Haworth is a tourist destination due to a famous family of literary sisters: the Brontë family, who lived at the parsonage between 1820 and 1861. The Brontë sisters were responsible for classic English novels such as *Jane Eyre* and *Wuthering Heights*. The parsonage is now a museum dedicated to the life and works of the family. (Historic England Archive)

Opposite below: Ilkley
Verbeia is the name of the small Roman fort at Ilkley, which is thought to have been too small for cavalry and therefore more likely to have housed an infantry cohort. The earliest inscription dates discovered at the site are from the latter half of the second century, but it is believed that Verbeia may have been used in the campaigns of Julius Agricola around AD 78. It is also thought that the site was abandoned quite early during the period of Roman occupation. Excavations carried out in the 1960s exposed part of a drain and the west wall. (Historic England Archive)

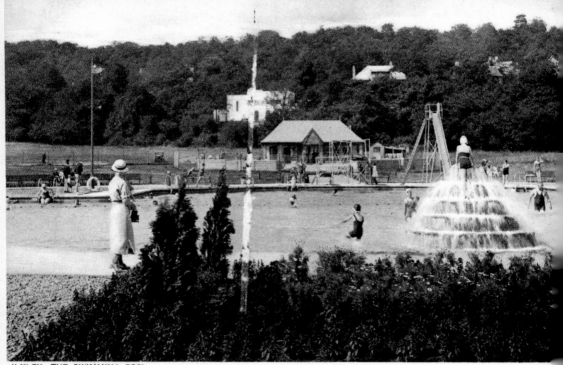

ILKLEY, THE SWIMMING POOL

Ilkley
This photograph is of the outdoor swimming pool and lido in mid-1900s Ilkley. The outdoor pool is now only open from the spring bank holiday until September (or the end of the season). (Historic England Archive)

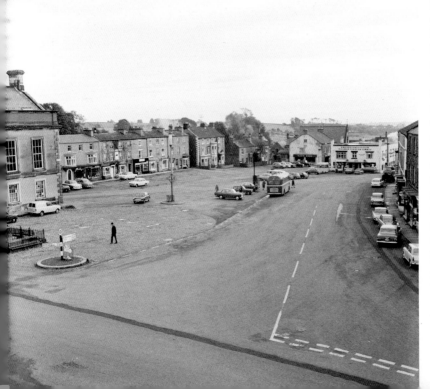

Leyburn
Now considered the capital of Wensleydale, Leyburn is a typical Pennine market town at the head of the Yorkshire Dales. The town was no more than a hamlet in its early life and its stature only increased when Charles II granted the town a market charter in 1686. The town may have grown in importance due to the fact that Leyburn is at the confluence of many roads linking local towns like Bedale, Richmond and Hawes. (© Historic England Archive)

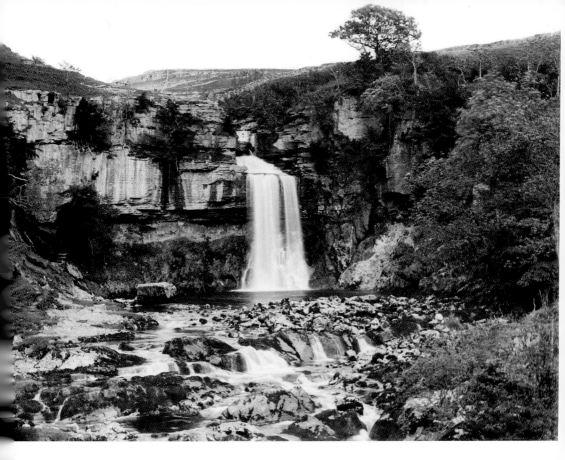

Thornton Force
Thornton Force on the River Twiss, around a mile north of Ingleton, falls 90 feet into a pool below. The waterfall is part of a 4.4-mile circular trail and part of a Site of Special Scientific Interest. (Historic England Archive)

Janet's Foss
Janet's Foss is a picturesque waterfall situated near Malham in the Yorkshire Dales and carries Gordale Beck over a limestone outcrop into a deep pool below. On the path towards Janet's Foss there are some tree stumps where other travellers have inserted hundreds of pennies for luck and made a wish to Janet, 'the Queen of the Fairies'. (Historic England Archive)

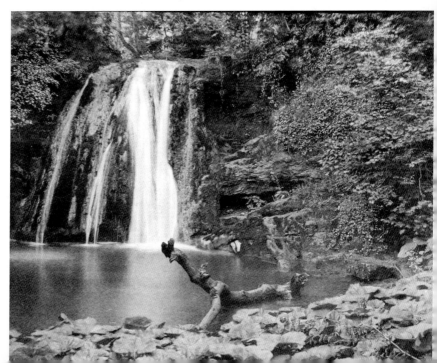

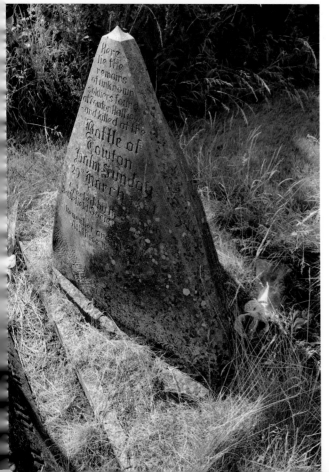

Above and left: Towton Battlefield
Yorkshire has its fair share of battlefields.
One of the most significant battles,
and considered the bloodiest ever on
English soil, was the Battle of Towton in
1461 during the Wars of the Roses. These
photographs show the memorial cross on
the battlefield and the covering stone in the
local churchyard, which marks the burial
of many combatants. Other significant
battles on Yorkshire soil include the Battle
of Stamford Bridge in 1066, the Battle of
the Standard (near Northallerton) in 1138,
the Battle of Boroughbridge in 1322, the
Battle of Wakefield in 1460 and the Battle
of Marston Moor in 1644. (Author)

Selby

Selby was also a major port and had a thriving shipbuilding industry before a general decline along with other industries. The last Selby-built ship was launched in 1998 and the toll bridge pictured here was used less and less. Because of its importance the Royalists under John Belasyse fortified Selby, erecting barricades and flooding the fields to one side of the town. Lord Fairfax and his son, Sir Thomas Fairfax, decided to attack from three directions at once, hoping to find the weak point in the town's defences and penetrate them. Once they broke inside the defensive ring they expected to secure victory with ease. After a fierce resistance, the town fell. (© Crown copyright. Historic England Archive)

Goole

The history of Goole begins when the Dutch engineer Vermuyden diverted the River Don by 10 miles to make it flow into the River Ouse rather than the River Aire. This was done at the request of the king, who liked to go hunting on Hatfield Chase near Doncaster and was fed up with the land always flooding. This action also allowed the land around Goole to become much more habitable. In 1826, when the Aire & Calder Navigation Company built a canal from Leeds to Goole, the town expanded as a trade centre, exporting coal from the West Riding of Yorkshire to the Continent. (© Crown copyright. Historic England Archive)

Fort Paull

The Humber Estuary was protected by an early castle, but later this protection took the form of Tudor blockhouses and gun positions, which were expanded during the Napoleonic Wars. Near the village of Paull, which is located 4 miles upstream from the port on the northern banks of the river, was an earthwork battery equipped with six 24-pounder guns. This site had previously been fortified during the Civil War when Royalist forces, who were besieging the pro-Parliamentary town, had built an earthwork fort to prevent supplies being brought up the Humber.

With the introduction of iron-clad warships, a royal commission was established to review coastal defences and the Paull Point Battery was constructed on the site between 1861 and 1864 to bolster the defences. The following years and conflicts saw modifications and change of use until it was decommissioned in 1956 and sold five years later. The site has now been converted into a museum, known as Fort Paull, and includes an eclectic mix of military-themed exhibits, including the last Beverly transport aircraft. (Author)

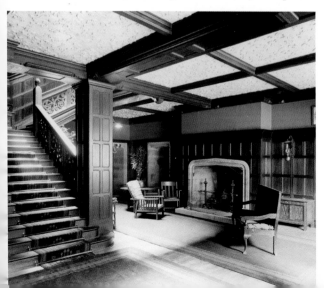

Hooton Pagnell

A beautiful South Yorkshire village built as part of the estate of Hooton Pagnell Hall, there may have been a building on this site from as early as 1089, and the current hall is built on the site of the earlier medieval one. In the late 1600s the hall was bought by the Warde family and has been in their possession ever since. This is a photograph of the fireplace in the hall with the staircase to the left. Though it was taken in 1904 it would be similar to how it looked during the First World War when Julia (Sarah) Warde-Aldam opened the hall up as a hospital to treat wounded soldiers. (Historic England Archive

Select Bibliography

History, Directory & Gazetteer of the County of York (1823)
History, Gazetteer and Directory of the East and North Ridings of Yorkshire (1840)
Seagrave, Harry, *Verbal Histories of Yorkshire*
Turner, Maurice, *Yorkshire Castles*
www.britainfromabove.org.uk
www.gatehouse-gazetteer.info
www.historicengland.org.uk
www.east-yorkshire-pages.org.uk
www.british-history.ac.uk
www.english-heritage.co.uk

About the Author

My other books include *Secret Richmond & Swaledale*, *Secret Barnard Castle & Teesdale*, *Secret Kendal*, *Secret Penrith* and *A–Z of the City of Durham*.
My Facebook page is 'Andrew Graham Stables' and is regularly updated with my latest projects.

About the Archive

Many of the images in this volume come from the Historic England Archive, which holds over 12 million photographs, drawings, plans and documents covering England's archaeology, architecture, social and local history.

The photographic collections include prints from the earliest days of photography to today's high-resolution digital images. Subjects range from Neolithic flint mines and medieval churches to art deco cinemas and 1980s shopping centres. The collection is a vivid record both of buildings that are still part of everyday life – places of work, leisure and worship – and those lost long ago, surviving only in fragile prints or glass-plate negatives.

Six million aerial photographs offer a unique and fascinating view of the transformation of England's towns, cities, coast and countryside from 1919 onwards. Highlights include the pioneering photography of Aerofilms, and the comprehensive survey of England captured by the RAF after the Second World War.

Plans, drawings and reports provide further context and reconstruction artworks bring archaeological sites and historic buildings to life.

The collections are housed in a purpose-built environmentally controlled store in Swindon, which provides the best conditions to preserve archive items for future generations to enjoy. You can search our catalogue online, see and buy copies of our images, as well as visiting our public search room by appointment.

Find out more about us at HistoricEngland.org.uk/Photos
email: archive@historicengland.org.uk
tel.: 01793 414600

The Historic England offices and archive store in Swindon from the air, 2007.